Classical Architecture
and Monuments of
WASHINGTON, D.C.

Classical Architecture and *Monuments* of
WASHINGTON, D.C.

A HISTORY & GUIDE

MICHAEL CURTIS

THE
History
PRESS

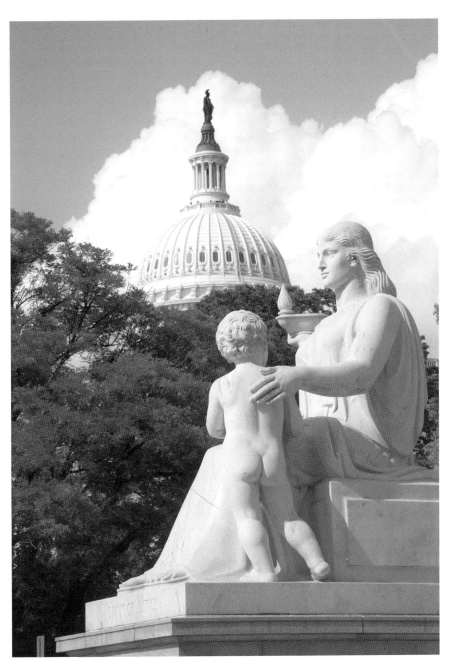

Carl Paul Jennewein's *The Spirit of Justice* beneath the Capitol Dome. *Spiritofamerica*.

Published by The History Press
Charleston, SC
www.historypress.net

Copyright © 2018 by Michael Curtis
All rights reserved

First published 2018

Manufactured in the United States

ISBN 9781625859716

Library of Congress Control Number: 2017955903

Never by dishonesty or cowardice shall we bring disgrace to this our city; we shall defend her constitution, her ideals and sacred ways, when alone or in rank; we shall with reverence obey her laws and inspire respect for her among our elders: Unceasingly we shall strive to quicken our sense of civic duty and we vow to transmit to our posterity a greater, stronger, prouder and more beautiful city than was granted to us. May the Gods be my witness.

—"Oath of the Athenian Youth"
Translation, the Ephebic Oath as reported by Lycurgus

CONTENTS

Contents

CONTENTS

OUR CLASSICAL HERITAGE

These tours are fashioned for those who wish a greater understanding of why and how the District of Columbia came to be a classically designed city. Whether you are a visitor to the District or a native, you will appreciate your nation's capital in new ways. You will learn of the ancient antecedents of our political philosophies, of the stylistic precedents of our architectural forms, and of the Founders' classical vision. Along the way, you will see well-considered plans realized, you will learn how accidents of history amend ideas, and you will understand how progressive modernism eagerly destroys tradition. Mostly, you will enjoy the grandeur and the beauty of Washington, the District of Columbia.

OBJECTIVES

The purpose of these tours is to teach the principles of art and political philosophy as these principles were understood by the nation's founders. By teaching the principles, we might extend the life of our nation by preparing the future for new challenges to liberty. Each tour has an object of concentration:

WASHINGTON, THE CLASSICAL CITY
The ancient cause of liberty; the immediate reason for independence; the classical principle of our convictions; the aesthetic model of a civil society.

PREFACE

ANCIENT ROOTS OF CLASSICAL ORDER
American classicism; our Greco-Roman heritage of thought, language, government and art.

A REPUBLIC OF VIRTUE
Republics need virtuous citizens; forms of government, thought, art and actions that cause virtue.

NATIONAL, POLITICAL AND PERSONAL LIBERTY
The various aspects of liberty considered in exemplary statues.

FREEDOM AND SACRIFICE
A consideration of freedom, sacrifice and the architectural style best suited to remembrance.

SYMBOLS OF EMPIRE
Welcoming international responsibility; assuming the heritage of civilization; celebrating national character; extending liberty.

BRUTAL MISTAKES
Hubris and progressive misdirection; gradual abdication of citizen responsibility for morals and art; policy, an instrument to undermine traditional culture.

OF THE PEOPLE
The inspired creation of the Federal City; plans in design and accident; the life, service and sacrifice of residents local and national.

BRITISH AMERICA
We trace in Alexandria our growth from quaint colonial villagers to benevolent masters of the world.

These tours are likely to meander in and out of subjects as this or that question occurs. So, be prepared for challenges and delights.

PREPARATION

Because tours are limited in scope, supplementary reading is recommended to answer inevitable questions and to increase knowledge. A brief reading in preparation of each tour will prepare tourists to learn by seeing. An extensive bibliography is provided to those who would like a deeper understanding of ideas, events, and places. Because the Founders' vision of our republic is prerequisite to understanding this city, a working knowledge of the Constitution (including the original Bill of Rights) is recommended. You will find it helpful to carry the Declaration of Independence for occasional reference to the purpose, plan, art and architecture of the capital city.

ACKNOWLEDGEMENTS

These classical heritage tours were conceived for the National Civic Art Society to extend the Founders' aesthetic vision and to teach founding principles. Erik Bootsma, AIA, first presented these NCAS tours for Hillsdale College's Kirby Center for Constitutional Studies and Citizenship. Justin Shubow provided observations to the text and leadership in organization. The Reverend Dr. Richard Allen Hyde lent the research and insight that formed Chapter V. Thanks to these men and to the many NCAS tour guides who have, through pleasant breezes, the icy slush of winter and sticky summer days, shared knowledge, pleasure and delight in this greatest of all world capitals, Washington, the District of Columbia.

WASHINGTON:
THE CLASSICAL CITY

L ooking over the expanse of our National Mall, we see 250 years of 4,000 years of human habitation. We cannot know which tribes populated Potomac's shores when Achilles fought Hector on the plains of Troy, but we do know that the Potomack lowlands were occupied by the Piscataway Indians when, in 1608, Captain John Smith explored the territory in preparation for English settlement. After the area was made secure for settlement, George Washington surveyed Alexandria, Virginia (once a part of Washington, the District of Columbia), and helped to form the streets on a regular, right-angled, ten-acre plan—the typical unit of Roman planning, which happens to be the area that a Roman citizen could plow in a day.

The local Algonquian speakers had anglicized or migrated when George Washington received an education in English civil society. Although of the middling rank, Washington inherited Western Civilization in the same manner that the typical Roman boy received education in public life and the family trade. Alike the Roman Cincinnatus, Washington was born into a family of planters who managed slaves, who were engaged in community leadership, and who provided military security. In addition to learning the arts of the farm, George studied history, sermons, surveying, building, Homer (in Latin) and other authors through tutors in the manner of young Cincinnatus. Likewise, others of the nation's founders received an excellent classical education: Thomas Jefferson was entered in English school at five years, Latin school at nine years, he was taught some Greek by a correct

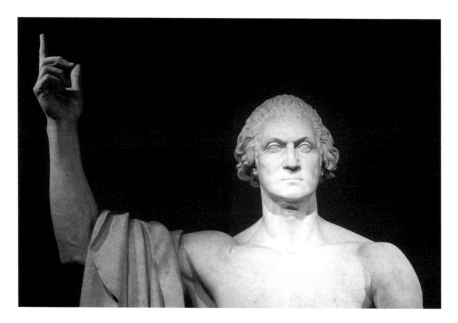

Horatio Greenough's *Enthroned Washington* (detail). *Spiritofamerica.*

classical scholar, and he then studied for seven years at the College of William and Mary. In his maturity, Thomas Jefferson was among the most educated of living men. Washington, Jefferson, Adams, Madison, Franklin, Hamilton, et alia guided the nation intellectually, shaped the nation politically, and formed the nation physically.

The Founders were also students of political history and of political economy; they well understood the vicissitudes of government; the necessity of separating the Federal City from state interference (see Hamilton and Madison in Federalist No. 43); and they understood that virtue is necessary in a republic. In his first annual address to Congress, 8 January 1790, George Washington detailed the importance of knowledge to a republic:

> *Knowledge is in every country the surest basis of public happiness. To the security of a free Constitution it contributes in various ways...to know and to value their own rights; to discern and provide against invasions of them; to distinguish between oppression and the necessary exercise of lawful authority; to distinguish between burdens proceeding from a disregard to their convenience and those resulting from the inevitable exigencies of Society; to discriminate the spirit of Liberty from that of licentiousness, cherishing the first, avoiding the last.*

IN A NAME

Alike Alexander the Great who chose the sites of his many ancient Alexandrias, President Washington chose the site of his federal city, the District of Columbia: that area bounded by the Potomac and the Anacostia Rivers, segmented by Tiber Creek. It is notable that the Potomac (*Patawomeck*) and the Anacostia are Algonquian place names and that the Tiber is a Latin place name. Pierre Charles L'Enfant (George Washington's city planner) intended to locate the sculptural embodiment of the nation's genius, where the source of Tiber Creek meets the base of Capitol Hill, *Liberty Hailing Nature Out of Its Slumber*.

The Pergamon *Alexander II, The Great*, in the style of Lysippos; Istanbul Archaeology Museum. *Diego Grandi.*

TOUR 1
THE NATIONAL MALL

TOUR SITES

THE NATIONAL MALL, FROM THE WASHINGTON MONUMENT

THE WASHINGTON MONUMENT

THE JEFFERSON MEMORIAL

CLASSICAL AMERICA

Preface

Today we visit the National Mall, sacred to the memory of the American people and to lovers of liberty everywhere. Here are the monuments of our founding, the memorials to our heroes, the treasures of the nation, and the seat of our republican government. All that you will see is formed in the classical tradition of our Greek and Roman inheritance through the Christian church into our Enlightened Age. Those recent Brutalist buildings, peculiar to the whims of individual designers, attempt to destroy the tradition, the forms, the history, even the language by which we pass virtue generation to generation. These brutal buildings are purposefully ugly in reaction to the refined classical tradition, as is the hammer struck on something beautiful a reaction, angry and violent.

Founders' Memorials

We find in the words we speak the architecture of Greek, of Latin, and of other ancient languages. These words have adapted themselves in use, gaining nuances of reference through place, through time. Likewise, classical building forms have deepened in meaning as they have adapted in use. Each generation over four thousand years has enriched the meaning of the form, the detail and the context of civic architecture:

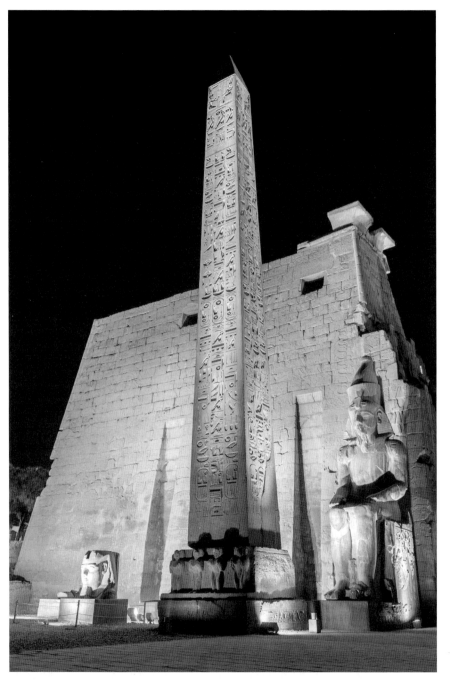

Ramses II (the Great) obelisk, 14 BC, Luxor Temple, Egypt, ancient Thebes. *Leonid Andronov.*

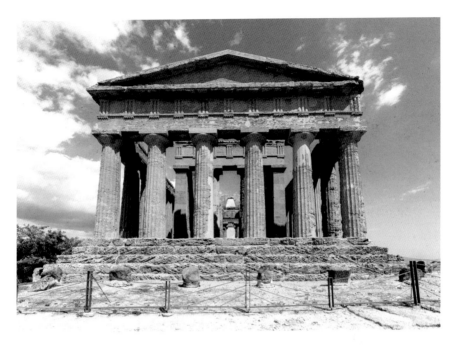

Temple of Concordia, circa 430 BC, Valley of the Temples, Agrigento, Sicily; among the best preserved of ancient Greek, Doric temples. *Vladimir Korostyshevskiy.*

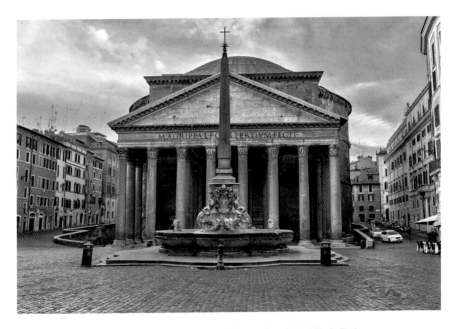

The Pantheon; Apollodorus of Damascus, architect, circa 120 AD. *S. Borisov.*

The Washington Monument, architect Clark Mills, inspired by the Egyptian obelisk (note that Mill's Doric stoa at the base has remained unrealized);

The Lincoln Memorial, architect Henry Bacon, inspired by the Greek Doric temple form (note Bacon's unusual side entrance);

The Jefferson Memorial, architect John Russell Pope, inspired by the Roman Pantheon;

The National Mall, architect Pierre L'Enfant, inspired by Versailles and the civic sciences.

When exploring the statuary, gardens and museums of the National Mall, we will discover many threads of the fabric of our history. Each thread will have a subject or reference, and that subject or reference will be of a style unique to a time in our tradition. The beliefs, hopes, and concerns of the artisan, sculptor, or architect will be told in the treatment of the form. For instance, Yixin's M.L. King Memorial will tell of that Chinese sculptor's training in Maoist art schools, Fraser's Ericsson Memorial will tell of heroic themes in our Western tradition and these statues will also tell of each sculptor's skill: see and compare the modeling, sculptural and linear volumes in King and Ericsson (notice the different treatment

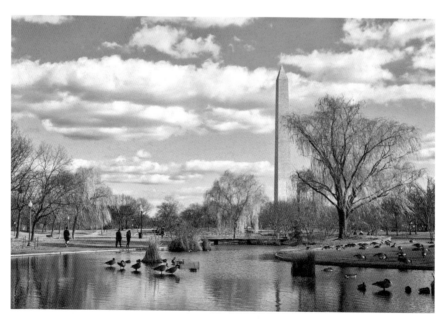

The Skidmore, Owings and Merrill Constitution Gardens' kidney pond, 1976. *Giuseppe Crimeni.*

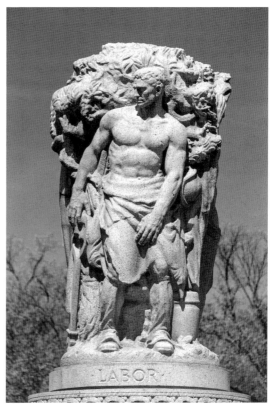

Right: *Labor* statue of the John Ericsson National Memorial; James Earle Fraser, sculptor, 1916. *Rob Crandall.*

Below: The rock cliff, potted plain and mud structure of the Museum of the American Indian. *Sophie James.*

of sculptural form in the carving of static and of breathing stone). Also, we might compare Yixin's King to D.C. French's Lincoln to contrast an adequate to a superior workmanship and to balance notions of the simple and the grand conception.

Since most Americans understand classical art and architecture through, well, the air around us—like fish, we live in water of which we are mostly unaware—and traditional works need only the introduction of the eye, I shall, therefore, leave you to see. Then, since the old-fashioned, modernistic style is a peculiar thing to each designer, and since you were not into modernism initiated, I offer with interpretive discrimination these brief notes on recent National Mall additions: the backyard kidney pond of Constitution Gardens; the diorama pastiche of the FDR Memorial; the 1970s art project of the Korean War Veterans Memorial; the elementary interpretation of the great architect Lutyens in the World War II Memorial; the scar in the ground of the Vietnam Veterans Memorial; the rock wall of the National Museum of the American Indian; the African American Museum's Yoruba crown (a royal symbol on a capital that, at its founding, rejected regal hierarchy) and no wonder that Congress has declared the National Mall "a finished work of art."

THE NATIONAL MALL
(1791–PRESENT)

Architects: Pierre Charles L'Enfant and the McMillan Commission: Burnham, McKim, Olmsted Jr., et alia

THE MARSHY TIBER

The early history of Washington, D.C.'s geography is hazy, yet we know a few particulars. We know that when Francis Pope acquired the property in the XVII Century he renamed "Goose Creek" the "Tiber" and preferred himself "Pope of Rome on the Tiber." We know that the creek was surrounded by tidal flats that often flooded after heavy rains, that its shores were marshy, that it was deep (John Quincy Adams nearly drowned when swimming here), that it was dotted with soggy trees, that its puzzle of ponds welcomed herons who dined on fishes and eels, and that its hollow bed now gapes beneath the sinking FBI Building. We know that the residents of the plotted towns of Carrollsburgh and Hamburgh, which flanked the marsh, would have been overborne by disease-bearing mosquitoes.

THE FOUNDERS' VISION

Fittingly, the nation's capital was determined at a brokered dinner in a compromise between Alexander Hamilton and Thomas Jefferson: Hamilton

hoped to establish a system of public credit and needed votes, which Jefferson would deliver if the nation's capital should be located in Virginia; the political bargain was agreed, and thus the capital was established in Jefferson's Virginia, ten miles north of President Washington's home, Mount Vernon. It must be said that the nation's founders were great men in the classical tradition of great men, that they were shaped by a classical education in Roman republican ideals, Athenian democratic philosophy, Christian virtue, and Enlightenment reason, and it should be said that our nation is classically formed. Thomas Jefferson, in a letter to Pierre Charles L'Enfant, expressed his intent that the capital be designed after "the models of antiquity, which have had the approbation of thousands of years."

PIERRE CHARLES L'ENFANT (1754–1852)

L'Enfant was the French-born American civic artist who designed the plan for Washington, the District of Columbia. His 1789 letter to President George Washington is telling: "No nation had ever before the opportunity offered them of deliberately deciding on the spot where their Capital City should be fixed, or of combining every necessary consideration in the choice of situation."

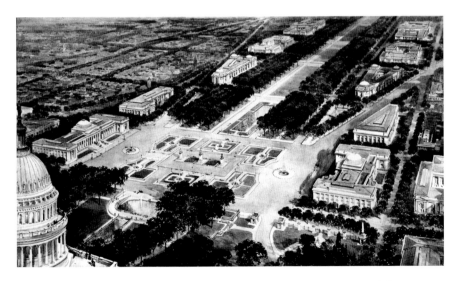

Union Square (not anticipated by L'Enfant), government and Smithsonian buildings; Charles Graham, watercolorist, 1902. *U.S. Commission of Fine Arts.*

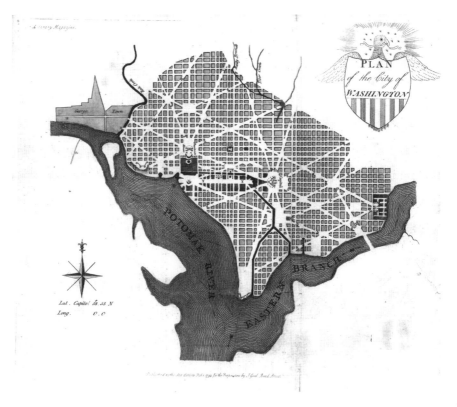

Plan for the City of Washington; L'Enfant Plan as modified by Andrew Ellicott, 1792; published, *Literary* magazine and British review, 1793. *Library of Congress.*

Of the Mall, L'Enfant wrote that it was to be "four hundred feet in breadth, and about a mile in length, bordered by gardens, ending in a slope from the houses on each side," referring to the President's House and the Capitol. Further, in regard to the plan's character, he wrote that "all such sort of places as may be attractive to the learned and afford diversion to the idle," which seems prophetic of the Smithsonian Institution.

THE McMILLAN PLAN (1902)

The Senate created a commission to return D.C. to the Founders' classical vision following the excesses of XIX-Century Romanticism. The members of this commission were also the directors of the 1893 World's Columbian

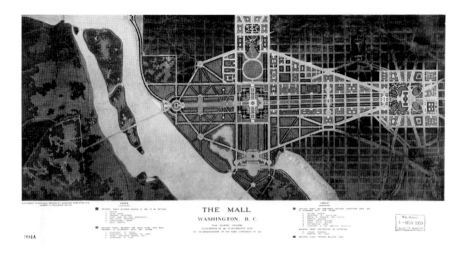

The Mall, Washington, D.C.: McMillan Plan development to 1915, in accordance with the recommendations of the Park Commission of 1901. *Library of Congress.*

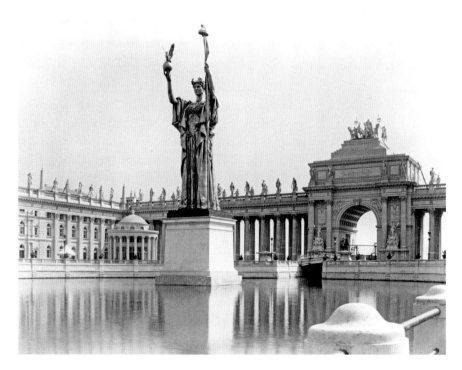

World's Columbian Exposition; Daniel Chester French's *Republic* standing before C.B. Atwood's Grand Arch of the Peristyle, 1893. *Everett Historical.*

Exposition, which inspired the City Beautiful Movement. The members included Daniel Burnham, Frederick Law Olmsted Jr., Charles McKim and Augustus Saint-Gaudens; the plan was named for Senator James McMillan, R-MI.

THE WASHINGTON MONUMENT
(1848–1884)

Architect: Robert Mills

Obelisk

A tall, sometimes enormously tall stone monument know as *tekhenu* by ancient Egyptians and as *obeliskos* by the Greeks; the word "obelisk" comes to us through the Romans in whose traditions we share. Typically, an engraved obelisk tells in hieroglyphs, pictographs or words the life of the pharaohs and the purposes of the gods. Some of the world's most famous obelisks include the obelisks of Ramses II, Temple of Luxor, ancient Thebes (one of which is in Place de la Concorde, Paris); the obelisk of Tuthmosis III, Constantinople; and the Wellington Monument, Dublin.

The Washington Monument

Built to commemorate George Washington, first president of the United States, the Washington Monument is composed of marble, of granite, and of bluestone gneiss; alike ancient obelisks, it is engraved, yet unlike ancient obelisks, its engraved poetic and prosaic inscriptions are found on the monument's interior walls, where they can be read bottom to top by stair or by elevator. At 555 feet 5⅛ inches, the Washington Monument is the world's tallest obelisk, and it was, until construction of the Eiffel Tower, the

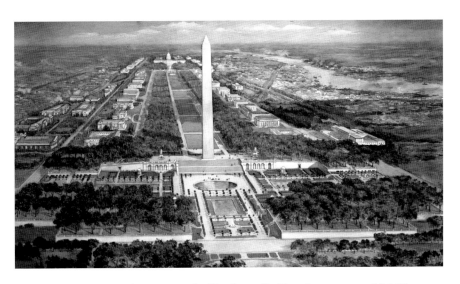

Washington Monument Gardens, overlooking future Smithsonian museums, McMillan Plan; Charles Graham, watercolorist, 1902. *U.S. Commission of Fine Arts.*

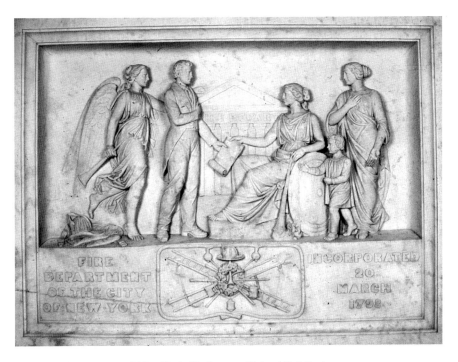

The "Fire Department of New York City" stone. *National Park Service.*

tallest man-made structure in the world. Look closely along the monument's towering height to find a change in stone color at approximately one-third height, a change occasioned by several coincidences: the private funding effort interrupted in 1855 by a Know-Nothing (an orthodox political party neither Republican nor Democrat) board coup; the bankruptcy of the stone quarry during crisis and violence of the War to End Slavery; and the federal government's delayed political reorganization, which postponed funding until 1876. Other changes cannot be seen: the preferred Doric stoa with Egyptian sun quadriga, designed by Mills and approved but not yet constructed and the pleasure gardens surrounding the monument, suggested by the McMillan Commission and included in the unfinished McMillan Plan. Also, in observation from the Capitol Building, the White House, and the Lincoln Memorial, you will notice that the monument is off axis; it is so because the original location, the location designated by L'Enfant, proved unstable, and so the monument was moved to firmer ground some 390 feet west-northwest. You will find in the monument's original intended location the surprising, now charming Jefferson Pier, which marks the second prime meridian—Jefferson, intending independence from Europe, located at this spot the beginning line of longitude; the British Empire was at odds with Jefferson and continues to designate longitude's common zero at Greenwich, England, which is, to my mind, a most unfortunate decision. Both Washington and Jefferson might better serve as models by which the world is aligned.

GEORGE WASHINGTON

The "father of our country," the "first in war, first in peace, and first in the hearts of his countrymen," George Washington was the commander-in-chief of the army that won our independence from Britain, the presiding officer at our Constitutional Convention, the first president of these United States, a planter, surveyor, businessman, soldier, and model citizen. I have heard criticism of Washington for inheriting the historically universal practice of property in man; here, honestly and fairly, all understand that Washington's slaves were freed as law, humanity, and care would allow and that without Washington's support of the Declaration of Independence, which states that "All men are created equal," without his heroic sacrifice in war, his service in office, his example in life, slavery in the world would not have been so soon ended, if ended at all.

WASHINGTON'S LEGACY

George Washington is remembered for his private virtue, his devotion to civic duty, his military courage, and for the honor granted him by that first, greatest generation of Americans. Following discussions, more talk and numerous suggestions for a monument fitting to the magnitude of the man, Congress resolved in 1799 to create an equestrian statue, which in the manner of Congress was not dedicated until 1860 (also, see Clark Mills's stop-gap George Washington statue in Washington Circle). The people, having grown impatient with Congress, initiated on the 100th anniversary of George Washington's birth a competition for the monument: "The contemplated monument shall be like him in whose honor it is to be constructed, unparalleled in the world, and commensurate with the gratitude, liberality, and patriotism of the people.... [It] should blend stupendousness with elegance, and be of such magnitude and beauty as to be an object of pride to the American people."

ROBERT MILLS

Mills, arguably America's first natively trained architect, was well known for having created Baltimore's Washington Monument. There, a statue upon a column upon a crypt; here, Mills designed an obelisk in the ancient tradition with a uniquely American, Doric stoa surrounding the base. Other Mills buildings in D.C. are also informed by history: the U.S. Patent Office Building (now a Smithsonian museum) is informed by the Parthenon, and the Treasury Building is informed by the Ionic Order of the Erechtheion; Mills' Baltimore Washington Monument is informed by Trajan's Column.

THE JEFFERSON MEMORIAL

(1939–1943)

Architect: John Russell Pope
Sculptors: Rudulph Evans and Adolph Alexander Weinman

PANTHEON

A pantheon is a temple of the Gods (from the Greek *pan* "all" + *theios* "of or for the gods")—that is, until the XVI Century, when a pantheon or the pantheon building form was employed for illustrious persons. The most famous pantheon is the Roman Pantheon commissioned by Marcus Agrippa during the reign of Augustus. It is possible that the Pantheon was intended for Agrippa's private use, yet we know that it contained statues of many gods until it was converted to a Christian church, currently Santa Maria degli Angeli e dei Martiri (with statues of martyred saints). Its form has become prototypical: a circular body with an oculus in the dome and fronted with a portico and pediment.

THOMAS JEFFERSON

Perhaps more than any other American, Jefferson would deserve the honor of abiding in a pantheon. In discussing his many virtues, one hardly knows where to begin: a polymath who spoke five languages; a scientist; an inventor;

a philosopher, president of the American Philosophical Society, composer of the Declaration of Independence; a planter; a great architect whose unique style is called "Jeffersonian," whose home Monticello is among his many exemplary buildings of type; his numerous government posts including president of the United States; and I could go on.

JEFFERSON MEMORIAL

The memorial's shallow dome rests eloquently on a circular Ionic colonnade, which can be approached by ascending spacious steps toward a pedimented porch. The sculpted pediment is fitting to the theme, "Drafting the Declaration of Independence," A.A. Weinman, sculptor. Beneath the oculus of the 129-foot-tall dome is Rudulph Evans' bronze statue of Jefferson, the Enlightenment philosopher and statesman (this statue might succeed in narrative, yet it has not the gravitas to command the building). Upon the frieze below the dome is inscribed, "I have sworn upon the altar of God eternal hostility against every form of tyranny over the mind of man." Other notable inscriptions are from the Declaration: "We hold these truths

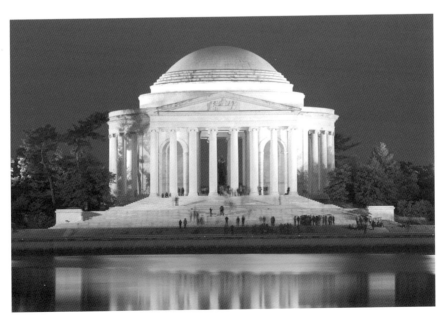

The Jefferson Memorial; John Russell Pope, architect, 1943. *Oleksandr Dibrova.*

to be self-evident: that all men are created equal, that they are endowed by their Creator…"; from a letter to George Washington: "God who gave us life gave us liberty. Can the liberties of a nation be secure when we have removed a conviction that these liberties are the gift of God…"; and many other sincere assertions.

JOHN RUSSELL POPE

Pope showed his sympathy for Jefferson in several architectural references. The dome recalls Jefferson's Monticello and the Rotunda at the University of Virginia; the colonnade is reminiscent of Jefferson's Virginia State Capitol; and the most charming, sympathetic touch: when seen from Meridian Hill Park, the Jefferson Memorial dome crowns the White House with that dome that Jefferson so dearly wanted.

TOUR II
CAPITOL HILL

TOUR SITES

THE UNITED STATES CAPITOL BUILDING

THE UNITED STATES SUPREME COURT

THE LIBRARY OF CONGRESS, JEFFERSON BUILDING

ANCIENT ROOTS OF
CLASSICAL ORDER

Today we will visit our nation's Capitol, court, and library, those buildings that comprehend Western Civilization's essential activities. Practically, these buildings are the public's government house, law house, and records house. These public houses, the nation's federal temples, ascend from the Greco-Roman temples of state gods. This is our foundation, our heritage: a Greco-Roman order of thought, of language, of government, and of classical temples through which our nation lives.

Each temple embodies the spirit of a practical activity, activities whose particulars are known in classical philosophy as problems: the Problem of Knowledge, the Problem of Conduct, the Problem of Governance. How we think of knowledge, conduct, and governance in physical form is also a subject worthy of our attention. Today, we will discuss how the intellectual and physical ideas of knowledge, conduct, and governance have modified over time to become three of the four most important buildings in the United States.

In this brief observation, we will discuss how history and political theory influence a building's form; how particular architectural styles and details embody abstract ideas; and how statuary and murals instruct and inspire. We will tour the exterior of the Capitol and the court. We will spend a quarter hour outside the library and half an hour inside, concluding at the porch of the stair. I am reminded that "if wishes were horses, then beggars would

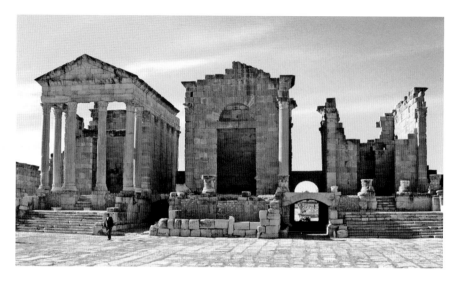

At Sufetula (renamed Sbeitla [Tunisia] after Muslim conquest) on the Capitoline Hill are found temples of Minerva, Jupiter and Juno (*left to right*); second century. *Bernard Gagnon.*

ride." I wish that I might escort each of you here reading, that together we might explore three of the most important buildings in human history, that together we might more fully comprehend ourselves, our country, and the character of a people born in liberty. Why? That when next we have the opportunity to create a memorial to our heroes, a monument to our principles, a shrine of national liberty, we might in the most suitable form, in style fitting principle, aptly, beautifully, and appropriately create buildings that inspire us to virtue in personal liberty.

In the tradition of classical inquiry, let us review each building's function and purpose:

A "library's function" is to hold records that will teach citizens the best of what has been thought, said and done; its purpose is the creation of ideal citizens.

A "courthouse's function" is to arbitrate disputes; its purpose is to allow commerce between citizens.

A "government-house's function" is to conduct the necessities of government; its purpose is to create a civil society.

Note: In our nation, the executive administers the state and commands the military from the President's House. The President's House is not today's concern. Does the physical form of each building suit its function and its purpose? Let us see.

THE UNITED STATES CAPITOL BUILDING (1793–1865), EASTERN FRONT

Architects: William Thornton, Benjamin Henry Latrobe, Charles Bulfinch, Thomas U. Walter and Montgomery C. Meigs
Sculptors: Randolph Rogers, Paul Wayland Bartlett, Thomas Crawford, Luigi Persico and Antonio Capellano

TRIPARTITE

Tripartite means "composed of three parts." Classical buildings are composed of three parts: they have a bottom, a middle, a top; a side, a center, a side; all parts have three parts, et cetera, and they are, most often, alike the human body, bilaterally symmetrical. Significantly, the federal government has three parts: the legislative, the executive, and the judicial. Originally, the Capitol housed the "House Chamber," the "Supreme Court Chamber," and the "Senate Chamber."

PORTICO

The temple portico's façade is composed of three parts: the base, the columns, the pediment. There are three basic, classical building orders: the Doric, the Ionic, the Corinthian (please see Appendix I). This is a Roman Corinthian order: Roman, as can be seen in the central pediment's high triangle—Greek

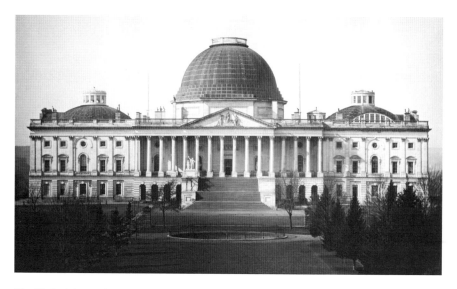

The United States Capitol Building, daguerreotype; John Plumbe, 1846. *Library of Congress.*

pediment triangles are lower—and Corinthian, as can be seen in the long column shaft culminating in the volute and acanthus capital. The Roman Corinthian is associated with stable government. *Notice Walter's tasteful refinement of the low-pitched Greek pediments of the House and Senate chamber additions (1850s), a refinement predicated by archaeological and scholarly research into the daily life, material culture, and political practice of Greek city-states, and here Walter's conscious use of the Greek over the Roman is a bold reminder of our allegiance with the Greeks in their War of Independence from the Ottoman Turks.

DOME

The dome of the Roman Pantheon inspired William Thornton (first architect of the Capitol) to design a dome for the United States Capitol. The dome's interior barrel matched the Pantheon's height, but the dome itself was later redesigned to challenge the great modern domes of Europe. The Pantheon was built to house all the Roman gods; in the VII Century AD, the Pantheon was converted to house the Triune God; this United States Pantheon houses American ideals.

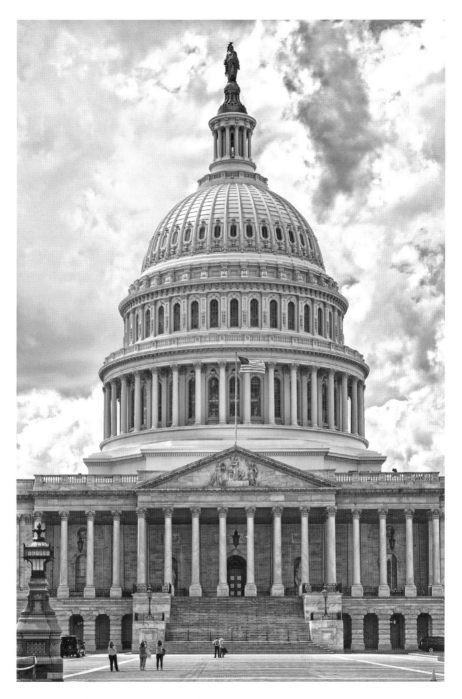

United States Capitol, Corinthian portico and dome. *Andrea Izzotti.*

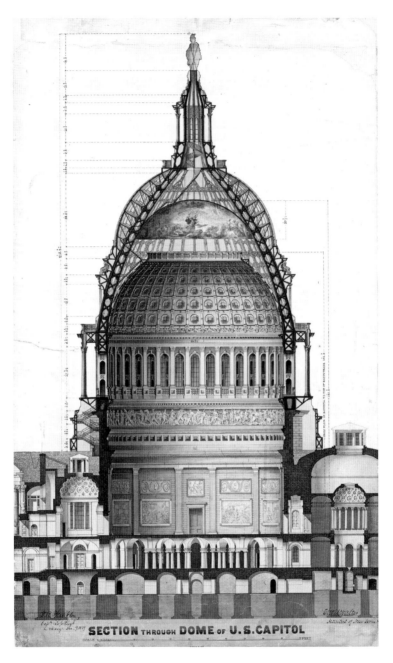

Section through dome of U.S. Capitol; Thomas Walter, architect, 1859.
Architect of the Capitol.

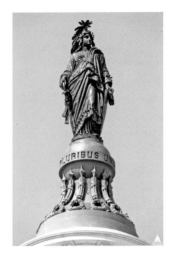

Freedom Triumphant in War and Peace surmounting the Capitol Dome; Thomas Crawford, erected 1863. *Daniel M. Silva.*

The *Columbus Doors*, describing the adventures, navigation, conquest, agriculture and commerce of Christopher Columbus; Randolph Rogers, 1855–61. *Architect of the Capitol.*

FREEDOM

Atop the dome stands the colossal *Freedom Triumphant in War and Peace*, later insipidly renamed *The Statue of Freedom*. She holds a sword, for war; a shield, for defense; a laurel wreath, for peace; she looks toward the rising sun. Thomas Crawford created this statue in his Rome studio.

COLUMBUS DOORS

These are also known as the Rogers Doors for their creator, Randolph Rogers, who presumed that his American doors would by circumstance be the greatest in the world, and in some particulars they might be. The doors, in exquisite detail, picture true and telling scenes in the life of Columbus— you will not here see pictured the currently popular, villainous Columbus myth. Of these remarkable doors it must be mentioned that mid-XX-Century progressive artist J.P. Slusser, professor at the University of Michigan, ordered Roger's original cast "Columbus Doors" into a city dump, along with statues by D.C. French, et alia—another typically progressive iconoclasm. Notice the sympathetic, ethnographic statuettes of the continents, and see the active portraits who witness from the tondos the pictured scenes of Columbus' life and adventures.

PEDIMENTS

The "Apotheosis of Democracy," says Paul Wayland Bartlett (sculptor of the House pediment), represents the life and labors of a people who "should be portrayed on this building, this temple of democracy." Thomas Crawford (sculptor of the Senate pediment) believed that sculpture may well be devoted to the perpetuation of what the people understand; that is, a correct comprehension of *The Progress of Civilization*. *Notice the original XVIII-Century Capitol building design, the low domes above the legislative chambers; the great XIX-Century dome crowned with *Freedom Triumphant in War and Peace*, here L'Enfant's observation of "a pedestal waiting for a monument" is doubly fitting; then, too, you might like to know of the XX-Century erasure of historically accurate, conceptually necessary statuary, *Enthroned Washington*, *The Rescue*, *The Discovery of America*, images and ideas banned by the censorious impulse. We shall be the nation of our Founders or some other thing: What America becomes will depend upon the philosophical principles by which it is formed and by those persons, histories, myths and legends to which we are loyal.

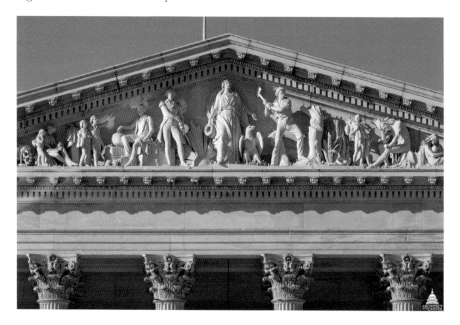

The *Progress of Civilization* pediment; in the center, allegorical America, flanked by an eagle and the rising sun. *Architect of the Capitol.*

THE PROBLEM OF GOVERNANCE

Are human beings by nature equipped to govern themselves; do some by right govern others: this is the problem of governance, a problem addressed through tyranny, oligarchy, monarchy, theocracy, communism, and liberty with consequences in the formation of law, society, and individual character. Here, the etymology of three terms will be serviceable: *demos*, Greek, "the people"; *demokratía*, Greek, "rule of the commoners" (*demo* = "people" + *cracy* = "rule"); vox populi (Latin, *vox populi, vox dei*, "the voice of the people [is] the voice of God"), from the medieval Latin, *Nec audiendi qui solent dicere, Vox populi, vox Dei, quum tumultuositas vulgi semper insaniae proxima sit*: "Those people who say, 'the voice of the people is the voice of God' should be ignored, because the riotous crowd is nearly always crazy."

You might be interested to know that Aristotle through the Lyceum composed constitutions for expanding Greek city-states, as did Plato, in spectacular failure when applying the ill-conceived *Politeia* to Syracuse (*politeia*, "the regime of political power"; "*The Republic*" is a gross, misleading translation of Plato's title and intent). Cicero, alike Plato, wrote dialogues, and his dialogue of political consideration is entitled *De re Publica*, a consideration that mirrors most directly our idea of limited democracy, a constitutional "Republic"—a republic in opposition to George III's monarchy, a republic very much alike Cicero's republic, in animadversion to Julius Caesar's dictatorship.

The Founders of these United States, in understanding themselves, understood that people are inclined to error, especially when moved by passion, and that democracy, alike monarchy, tends to tyranny, a tyranny that the Founders meditated by creating the several branches—executive, legislative, judicial—each branch chastening the other, and this chastening, this contemplation, this cooling, this delay has prevented us from tearing one another apart. You might like to picture the American ship of state as carrying three women, thirsty, hungry, with limited rations, adrift at sea. In a democracy, two could vote off the third, tossing her to the whim of the fishes so that the floating two might win the tossed woman's rations; in a republic, each has a right to life anterior to the vote, so no one is tossed— perhaps the three women will in cooperation discover a solution, perhaps the bickering three will together starve, who can say. The informed, classical, tripartite United States Capitol building acknowledges the triune nature of our republic, its summoning classical precedent and the hard, sometimes violent lessons of political history.

THE UNITED STATES SUPREME COURT (1929–1935)

Architect: Cass Gilbert

Sculptors: James Earle Fraser, Robert Aitken, Herbert Aitkin and John Donnely

BUILDING

The United States Supreme Court building is a temple of justice, our temple of justice; it is in form a Roman basilica whose sacred chamber is approached up rising steps, beneath a high columned portico, along a dignified quiet entry, through a stately grand hall, into the shrine of the god, here transformed into a court of public redress where are heard issues that try the Constitution's wisdom. We can imagine centuries of such processions tracing back to republican Rome and forward into our future. Also, we are meant to feel the majesty of Law, and we do. We think of ancient Roman law, Renaissance Catholic basilicas, and yet we recognize this building to be that uniquely American form ascending through Thomas Jefferson's republican classicism.

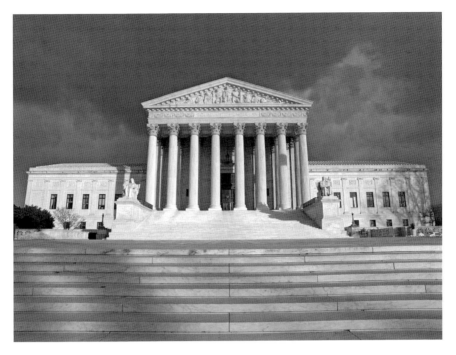

The United States Supreme Court building; Cass Gilbert, architect, 1935. *csp_trekandshoot.*

JUSTICE

There are many forms of justice, some suitable to republics, some not. In brief: Abrahamic justice derives from the Jewish God's commands and occasional mercy, with application directly to the Jewish people. Retributive justice is tribal, primitive in the assumption that the family or the tribe is responsible for the individual action; this is a justice of material and violent vengeance. Qur'anic justice encompasses for Muslims all matters of action and of thought; it is in structure both religious and political, mostly unsuitable to liberty and republics. Natural justice concerns those rights and responsibilities by reason derived from human nature, the precedents of which originate in Greek philosophy, Roman morals, the Christian Bible and those Enlightenment philosophers contemporary of this nation's founding.

THE PRACTICE OF JUSTICE

Athenian justice was debated in expansive, mostly open areas by a jostling, full-citizen assembly; Roman justice was issued in great public houses by praetors in edicts that were proclaimed during the comings and goings of the busy workday; American justice is tested by inquiry, is considered by jurists in quiet contemplation, is delivered with reserve, in occasional dissent, from the womb of this reputable House of Justice.

PEDIMENTS

The west front, "Equal Justice Under Law," pictures "Liberty" flanked by Roman soldiers "Order" and "Authority"; to the sides are the everyman, Cass Gilbert (architect), Robert Aitken (sculptor), C.E. Hughes (Supreme Court justice), William H. Taft (president), et alia, all going about their business. H.A. MacNeil's aesthetically superior east front, "Justice the Guardian of Liberty," pictures Moses (Hebraic law), Confucius (Chinese truisms), Solon (Greek law), Aesop's tortoise and hare and other symbolic persons. *When on site, notice how the large figures in the west pediment cause the building to look small and how the small figures in the east pediment cause the building to look large.

STATUARY

The immense statues enthroned before our Supreme Court share our transient human existence, yet they abide anterior to ephemeral time; in form, these statues are of us, yet unlike us, they are ideal in purpose, heroic, strong, composed, and through them we recognize those characteristics of ourselves that are timeless, classical, abiding. Here we recognize ourselves transfigured into the demigods of Law and Justice. The sculptor of these enormous, fifty-some-ton statues, *The Authority of Law* and *The Contemplation of Justice*, is James Earle Fraser, America's Sculptor of Empire.

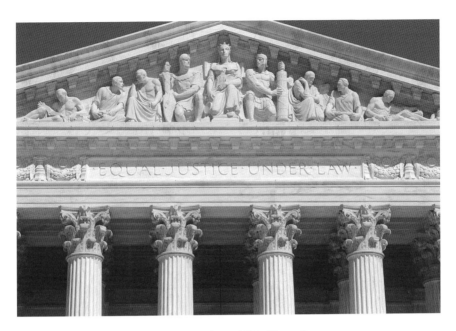

Equal Justice Under Law; Robert Aitken, sculptor, 1935. *Flysnowfly*.

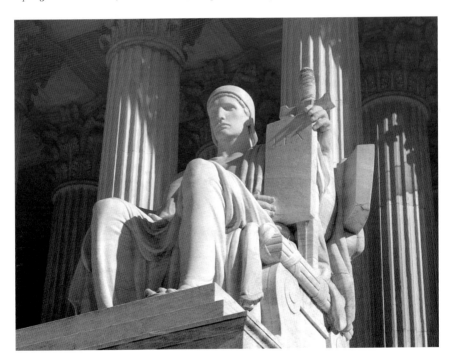

The Authority of Law; James Earle Fraser, 1935. *csp_trekandshoot*.

DOOR

The great bronze doors illustrate a history of human justice in eight panels:

1.) The Shield of Achilles: Homer reports that to replace the armor taken by Hector from the body of Patroclus, Hephaestion fashioned a shield depicting the pleasantries of civil life for that hero who would soon destroy one civilization (Troy) to complete his own (Greece).

2.) Praetor's Edict: A Roman praetor (officer of law) publishes a judgment of common law, which a soldier stands at the ready to enforce.

3.) Julian and Scholar: Julian the Jurist (AD 110–170) bequeaths Roman law to the next generation.

4.) Justinian Code: Justinian the Great (AD 482–565), emperor of the Eastern Roman Empire, publishes the Corpus Juris, the first codification of Roman law.

5.) Magna Carta: King John of England is by the barons compelled to place his seal upon the Magna Carta (Great Charter of Liberties [1215]), which prescribed that sovereigns live within the rule of law.

6.) Westminster Statute: King Edward I watches his chancellor read the Statute of Westminster (1275), which makes rights common to all Englishmen.

7.) Coke and James I: Sir Edward Coke bars King James I from participation in England's high court, thereby separating the judicial and executive branches of government.

8.) Marshall and Story: Chief Justice John Marshall delivering the *Marbury v. Madison* opinion, which declared: "Acts of Congress can be unconstitutional, and therefore, invalid." *Notice Justice Story in the *Marbury* panel: Justice Story's son, William Whitmore Story, created the famous statue of Justice John Marshall.

THE PROBLEM OF CONDUCT

How are we to behave? Can we be made to behave? These questions are considered legally, ethically, and practically. There are laws that are common to all people at all time, and there are laws specific to local conditions, those rules for ease and order applied to, let us say, "parking." Parking, murder—weigh them: one is local, conditional; the other, absolute, questionable only in self-defense, battle, abortifacients. All honest, sane persons can see, can weigh the difference. In this we rather agree with

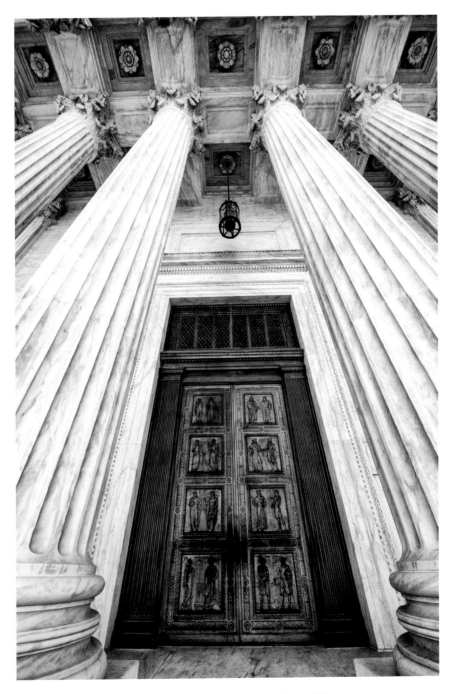

Supreme Court doors; John Donnelley Jr., sculptor, 1935. *Renaschild.*

Socrates, who understood that people will naturally do good, and better, the better they understand the good, for, by nature, people are not inclined to murder, yet we are inclined to overstay a parking meter; in this we understand that just laws are proportional, formative of our conduct in matters great and particulars insignificant.

The history of law contains its majesty (see earlier), and we are contained within it. The Justice comprehended by the people of these United States is informed by the Declaration of Independence and is codified by the Constitution of the United States (inclusive of the Bill of Rights). The Declaration and the Constitution assume that citizens are granted equality by a Creator anterior to government, that the Creator bestows life, liberty, and happiness, conditions that are secured by just laws, only so much as these laws comport to the consent of persons made equal by their Creator. This assumption, born in classical liberty, Platonic philosophy, Hebraic law, Christian virtue, and enlightened reason, forms the conduct of we Americans and forms the structure, beauty and majesty of the United States Supreme Court Building.

THE LIBRARY OF CONGRESS, JEFFERSON BUILDING (1871–1897)

Architects: John L. Smithmeyer, Paul Pelz and Edward Pearce Casey
Sculptors: Roland Hinton Perry, Bella Pratt, Olin Warner, Frederick McMonnies, Herbert Adams, F. Wellington Ruckstuhl, Daniel Chester French, John Flanagan, et alia
Painters: Kenyon Cox, Edwin Howland Blashfield, Gari Melchers, Elihu Vedder, Edward Simmons, Walter McEwen, et alia

Two Great Libraries

The Library of Alexandria, commissioned by Ptolemy I (III Century BC), likely contained 400,000 volumes (scrolls) and was for nearly one thousand years the largest library in the world. Aristeas reports that the purpose of the library was to assemble all recorded knowledge, "to collect, if possible, all the books in the world"; tellingly, an inscription above the stacks read, "The place of the cure of the soul"; knowingly, it was dedicated to the Nine Muses. The library enjoyed many famous directors and librarians, those who formed our library systems, criticism, et cetera, the first of whom was Demetrius of Phaleron, a student of Aristotle; the second, Callimachus of Cyrene, the "father of bibliography and librarianship," who developed a library catalogue system; Zenodotus, a philologist, inventor and father of "textual criticism"; Apollonius of Rhodes, author of "The Argonautica"; Eratóstones from Cyrene, a mathematician who measured the circumference of the Earth;

Aristarchus of Samothrace, who established that the Earth revolves around the sun; Aristophanes of Byzantium, who compiled a "lexicon" (Greek, "of or for words") and also divided poetry into *kolon*, "verses"—thank you, Aristophanes; and then mathematicians (Euclid, Archimedes, Theon of Alexandria), geographers and historians (Manetho and Diodorus, Strabo and Ptolemy), the botanist Theophrastus, philosophers, poets, astronomers, doctors, including Galen, et alia, et alia. Alike our library, the Library of Alexandria was burned: by Julius Caesar during the siege (48 BC); relocated and then sacked by the Emperor Aurelian (AD 270–275); reassembled and then burned by the Coptic Pope Theophilus (AD 391). The little that survived was with Paganism proscribed by Emperor Theodosius I (AD 391); reduced in the capture by the Muslim army of 'Amr ibn al-'Ast (AD 642); and finally extinguished by the Caliph Omar, who said, "If those books are in agreement with the Quran, we have no need of them; and if these are opposed to the Quran, destroy them."

The Library of Congress was founded in 1800 to provide for the necessary uses of Congress. In 1802, President Jefferson signed into law provisions for a librarian of Congress and for borrowing privileges by the president and the vice president. The library was burned in 1814 by the British (Anglo-American War); Jefferson's personal library of 6,487 books was purchased by Congress in 1815 to replace the burned books. Again, 35,000 of the library's 55,000 books were destroyed by the fire of 1851. Gradually, the Library of Congress became the national circulation library, containing more than 61 million artifacts stored in numerous buildings. The library's mission is "to develop qualitatively the Library's universal collections, which document the history and further the creativity of the American people and which record and contribute to the advancement of civilization and knowledge throughout the world, and to acquire, organize, provide access to, maintain, secure, and preserve these collections." How long and through how many changes our library might survive, no one can say. Worthy of note: The Library of Alexandria was constructed in the Brucheion (the Royal Quarter) in style alike the Lyceum, known to us through Aristotle, and it was associated with the Museum, the temple "House of Muses" (from whence our word "museum"), and here were gardens, fountains and halls for meetings, gatherings, et cetera, a place of recreation and improvement, much alike our National Mall.

The Building

As in all successful Beaux Arts architecture, the approach and entrance prepare a visitor for the building's meaning and purpose, and the floorplan guides a visitor effortlessly through the story and the uses of the building. In the Beaux Arts, all things are handsome, all things are logical; art and life become a single object. In this library is found, of what yet survives, the best of what has been made, said, and done: within the stacks and vaults, universal knowledge, history, biography, literature, invention; upon the walls, names, quotations, portraits, pictures, statues.

Spandrels and Doors

The spandrels above the entrance doors advertise the library's content in the allegorical figures of "Literature," "Art," and "Science." The bronze doors introduce the building's genesis by picturing in succession allegories of "Tradition," "Writing," and "Printing." The allegories open like a book to invite one into civilization's "Great Conversation."

Interior

Over the dome, on the lantern at the library's apex is the gilded *Torch of Learning*, below which is the interior vault of the reading room on which is painted the mural of *Human Understanding*, itself resting on an intertwined ring of allegorically figured national epochs and the arts or sciences that flourished therein. As you pass through the library on your ascent to the reading room's observation deck, pause to consider the meaning of the murals, recall what you know of the great names framed on the walls, remember the inscriptions for future application and pause here and there to enjoy beauty. *Notice the effect of classical ascent in the Library of Congress entrance and compare the mole-like modernist descent into the bowels of the new U.S. Capitol entrance.

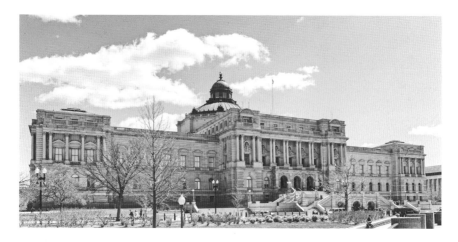

The Library of Congress, Jefferson Building; Smithmeyer and Pelz, architects, 1897. *Alexey Rotanov.*

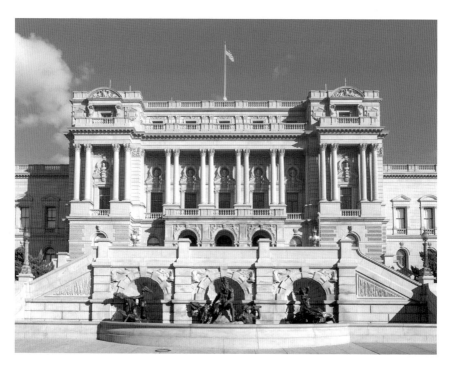

The Library of Congress, Jefferson Building, 1897; descriptive of diverse architectural details, spandrels, busts, statuary, et cetera. *Adam Parent.*

Fountain

The "Court of Neptune" might seem a curious subject for a library's fountain until we remember our nation's eager growth to empire and recall our inherited cultural competition with Europe's capitals that had their own Neptune fountains: Florence, Bologna, Madrid, Berlin, Rome, et alibi. Here, Neptune, brother of Zeus and Hades, is flanked by the female aspects of his power: Salacia, overbearing waters; and Venilia, tranquil waters. *Notice how civilization flows alike the dual nature of water, sometimes violently, sometimes placidly.

The Problem of Knowledge

How do we know what we know; do we know what we know—good questions that we answer through the practice of epistemology (Greek: *episteme*, "knowledge" + *logos*, "logical discourse"). Of proof, Plato well enough understood that through mathematics is found an ineffable reality true always and everywhere. We might know this reality of "that which is" through sensation, perception, conception, discussion, the comprehension of ontology (Greek: *onto*, "being, that which is" + *logos*, "logical discourse"), which, for Aristotle, is through fundamental entities. By Socrates, through Plato, we understand the necessity of examining all things, especially one's life, and virtue, that thing for men most worthy of knowing—virtue, that quality, that achievement, that comprehension which is the purpose of education.

All the many objects of this great Library of Congress, in ultimate cause, were assembled that we might acquire knowledge of "that which is" so that we can more fully participate in "those virtues which are the human being." This library is a fact of classical inheritance, the continuation of a tradition which some would stifle, which, through the intimidation of political correctness, some would extinguish. We know the ends of contemporary theory in education, we see them in the product of government schools: citizens incapable of knowing their civilization, persons ignorant of themselves. In the *Phaedo*, Socrates warns us that "there is no greater evil one can suffer than to hate reasonable discourse." And Orwell, that keen observer, many years ago foresaw how progressives intended to overwhelm the classical, the true, the beautiful, and the good: "The most effective way to destroy people is to deny and obliterate their own understanding of their history."

TOUR III
THE PRESIDENT'S HOUSE AND GARDEN

TOUR SITES

THE WHITE HOUSE

LAFAYETTE SQUARE

THE UNITED STATES TREASURY

A REPUBLIC OF VIRTUE

Preface

Montesquieu noticed that different forms of government require different dispositions in citizens: fearfulness under tyranny; honor under monarchy; virtue in republics. The republic's Founders, Jefferson, Adams, Madison, et alia, studied Montesquieu and chose the Roman form of republican government over the Greek form of democracy, as republics incline to success and are dissuasive of violent upheaval.

Virtue

The founding generations (1700–1776) were the most philosophically disposed in U.S. history; they read broadly in law and deeply in religion and were conversant in English rights, liberties, and natural law. The Founders understood Roman virtue through Plutarch, grace through the Bible, and God's benevolence through science. All recognized the qualities of virtue under law through the Enlightenment back to Aristotle's definition of the nature of rational beings.

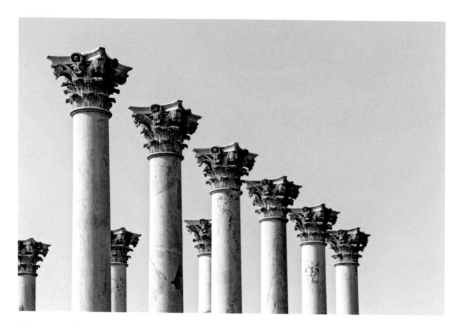

The original U.S. Capitol, Roman Corinthian columns retired to the National Arboretum. *Steven Heap*.

DECLARATION

The Declaration of Independence provides reasons for the formation of a new nation upon the earth; it rationally delineates the causes of independence before listing the train of tyrannical abuses; it is unique among political documents; it is the culmination of numerous experiments in colonial government; and it is the model of liberty that has realized the Enlightened Age.

CONSTITUTION

The Constitution of the United States is the outline under law of the realistic appraisal of what is acceptable in a community of free citizens; it is a plan of government guided by reason and inspired by the God of Nature; it attempts to constrain government from willful acts of tyranny.

BILL OF RIGHTS

The Bill of Rights enumerates what needs not be enumerated: "That men are endowed by their Creator with certain unalienable rights, that among these are Life, Liberty, and the pursuit of Happiness." ("Happiness" meaning a species of *arête*, a human flourishing or excellence.)

HOUSE

In this instance, the domestic home of the executive, ennobled by the office he holds.

SQUARE

An urbane place to gather, to recreate, to honor and here to remember the principled virtues and the exemplary heroes of America's War of Independence from Britain.

TREASURY

In antiquity, a place to hold votive offerings to the gods or booty from war; here, a portion of the accumulated wealth freely given by a people who have earned wealth as a consequence of economic liberty through both public and domestic virtue.

THE WHITE HOUSE
(THE PRESIDENT'S HOUSE) (1792–1801)

Architects: James Hoban, Benjamin Henry Latrobe, William Adams Delano and Charles Follen McKim

PALLADIANISM

Andrea Palladio (1508–1580) is the most influential architect in Western Civilization. Palladio's architectural theories owe much to Vitruvius (architect to the Emperor Augustus), whose architectural dictum, "Firmness, Commodity, and Delight," informed Palladio's architectural practice. Although Palladio did not create the villa form, the well-measured, historically accurate designs pictured in his *Four Books of Architecture* gave the villa form a second birth and helped to create a multinational Classicism, sometimes referred to as "Neo-Classicism," yet I prefer the term "Palladian."

FOUNDERS' HOMES

Before they were Americans, the Founders were Englishmen with continental tastes. Washington's Mount Vernon is a Palladian updating of (folk) Georgian, as is Madison's correct Montpelier; Jefferson's Monticello, too, is Palladian but formally unique. *Note how art and life and the emoluments of domestic and public virtue were closely linked.

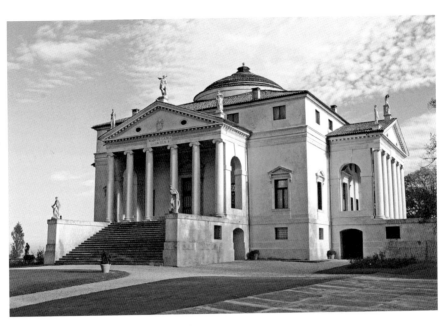

Villa Rotonda, Vicenza, Italy; Andrea Palladio, architect, 1571. *scatto79.*

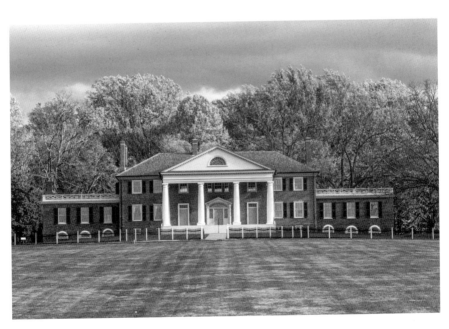

Montpelier, Montpelier Station, Virginia; James Madison, et alia, architects, 1760s–1812. *Pthomaskmadigan.*

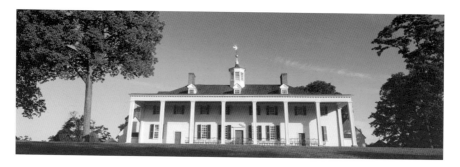

Mount Vernon, Virginia; George Washington, et alia, architects, 1778. *Spiritofamerica.*

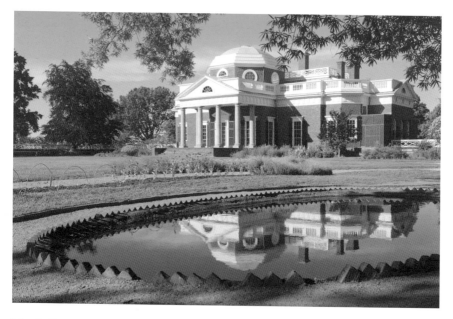

Monticello, Charlottesville, Virginia; Thomas Jefferson, architect, 1768–1826. *Konstantin L.*

THE PRESIDENT'S HOUSE

The President's House was carefully conceived in L'Enfant's Plan of Washington; it is located on axis with the Washington Monument; it is linked to the United States Capitol Building along Pennsylvania Avenue (Pennsylvania, the state where the Declaration, Constitution and Bill of Rights were composed); its design was chosen by competition (Thomas Jefferson submitted a domed design); and it was burned by the British in

1814 during the Anglo-American War (sometimes known as the Napoleonic War of 1812), after which it was whitewashed to cover the stains of smoke and of flame, yet it should be mentioned that the house had previously been painted white to protect the porous limestone from freezing.

ARCHITECTS

James Hoban won the competition to design the President's House with his Federalist interpretation of the Georgian Leinster House (Dublin). Federal architecture (named for our early Federal Union of States) is, alike the Georgian (named for the British Hanoverian kings), Palladian yet rather more restrained, tighter drawn and close to the chest. Hoban's original design was over-large for the unpretentious George Washington, who convinced Hoban that a two-story house was more fitting than a three-story version. Benjamin Henry Latrobe, friend and associate of Thomas Jefferson, undertook the elegant pavilion additions and gardens during Jefferson's presidency. Charles Follen McKim recovered the White House second floor from the excess of Victorian doodadism and oversaw the construction of the "West

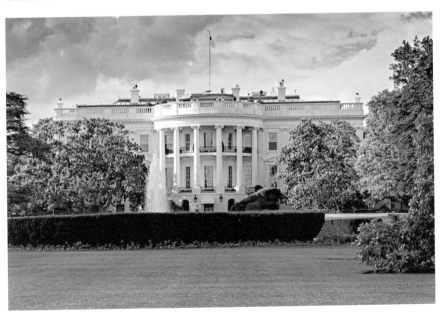

The White House, Truman Balcony; William Adams Delano, architect, 1948. *ESB Professional.*

Wing" for President Theodore Roosevelt's expanding staff (the 1943 "East Wing" serves the requirements of the first lady). William Adams Delano, cousin to President Franklin Delano Roosevelt, was asked by FDR to add an interior, third-floor residence—because the White House was becoming overcrowded with bureaucrats—and Delano also designed the controversial yet elegant Truman Balcony for President Truman. The Truman Balcony was President and First Lady Obama's favorite room; it is rumored that industrious President Trump's favorite room is the iconic Oval Office.

EOPOTUS

A panel of progressivist political scientists and administrators created the "**E**xecutive **O**ffice of the **P**resident **of** **t**he **U**nited **S**tates" that Franklin D. Roosevelt might bring under one roof the existing executive departments and many new departments created by Roosevelt's executive orders. Today, the name "White House" refers as much to executive power as to the original intention of a home for the president and his family, yet the idea of the first family remains central to national identity.

LAFAYETTE SQUARE (SEPARATED FROM WHITE HOUSE GROUNDS IN 1804, UPDATED 1930)

Architect: Andrew Jackson Downing
Sculptors: Clark Mills, Jean Alexandre Joseph Falguière, Fernand Hamar, Antoni Popiel and Albert Jaegers

PRESIDENT'S PARK

Before the effective mote of Pennsylvania Avenue, and before the president became an inmate of a gated, guarded White House, the square was the president's extended front lawn. Here, for a time, the square was known as "President's Park," the pleasure grounds where the president and his family would take their leisure. Since then, the square has been employed as a soldiers' encampment, a racehorse track, a zoo, a slave market, a flophouse, and other uses that should not be mentioned (well, perhaps just one; here D.C. district attorney Key was murdered by Congressman Sickles for Key's dalliance with Sickles' wife).

LAFAYETTE SQUARE

In 1824, the square was renamed "Lafayette Square" for Major General Marquis Gilbert de Lafayette (the French aristocrat and general of the Continental army under George Washington). Lafayette hoped to inspire

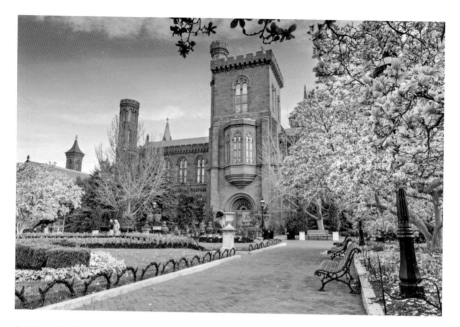

Smithsonian Institution Building, "The Castle"; James Renwick Jr. *Sean Pavone.*

the spirit of revolution in the people of France, which he did with tragically bloody success—the French Revolution was spiteful and cruel, unlike the lawful, ennobling American War for Independence. While about the square, you might want to visit Latrobe's Decatur House, named for our naval hero Stephen Decatur; Latrobe's St. John's Episcopal Church, the "Church of the Presidents"; and America's first museum by design, the Renwick Gallery, named for the architect James Renwick Jr. Of the other residents, social life and buildings, General McClellan, W.H. Seward, Senator J.C. Calhoun, the remarkable Henry Adams, et alia and et cetera, there is, unfortunately, insufficient space to expand.

PICTURESQUE STYLE

In 1851, landscape architect Andrew Jackson Downing reshaped the square in the Picturesque manner, a manner alike a picture expressive of the beautiful, the rustic, or the sublime. To picture the sublime you might think of the Romantic poets: Coleridge in the terrifying "Kubla Khan," Shelley in the grandiose "Ozymandias," or Goethe at the conclusion of "Faust." To picture the rustic, imagine Downing's forestation of the Nation Mall, where

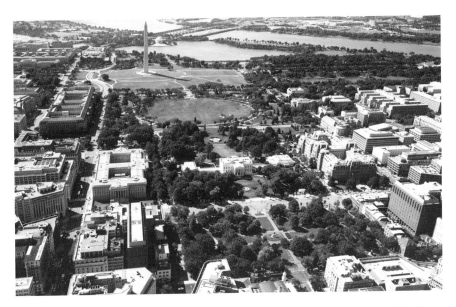

Overlooking Presidents Park (Lafayette Square, the lower green); Andrew Jackson Dowling, landscape architect, 1852. *Carol M. Highsmith.*

James Renwick Jr.'s Smithsonian Castle made its home. In the instance of Lafayette Square, Downing appropriately employed the beautiful mode of the Picturesque, a graceful gentleness of flora that punctuates the strict symmetries of the hard paths. The current Lafayette Square is a sympathetic adaptation of the Andrew Jackson Downing design.

STATUES

Statues represent exemplary citizens, heroes, and allegorical divinities. Statues exist in the higher realm of being, in form alike a man, yet in essence a transcendent idea realized. Statues are intelligently composed, aesthetically resolved, expertly crafted tributes to civic, military, or humanitarian accomplishment. Statues are not the bronzed mannequins that occupy park benches frozen in absurd Kodak poses; these mannequins, this popular species of kitsch, should not be confused with civic statuary. It would seem, by the evidence of multiplying mannequins and diminishing statues, that we are a people in taste, quality, and discernment much degenerated from our great, very great grandparents.

HEROES

The statues that demarcate the park depict the military virtues and represent the heroes of the War for Independence: southwest, General Comte Jean de Rochambeau of France; southeast, Major General Marquis Gilbert de Lafayette, elegantly modeled by Falguiere; northeast, Major Brigadier General Thaddeus Kosciuszko of Poland, military architect and engineer; northwest, Major General Friedrich Wilhelm von Steuben of Prussia, author of "Regulations for the Order and Discipline of the Troops of the United States," finely modeled by Jagers. The central statue, the *Andrew Jackson* by Clark Mills, was erected in 1853 and was the first equestrian statue cast in the United States. Remarkably, with an American ingenuity, Clark Mills built a foundry to cast the ten-piece statue; this piecing together accounts for the statue's stiffness.

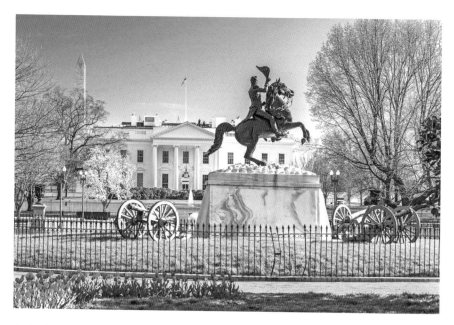

Andrew Jackson, Lafayette Park; Clark Mills, sculptor, 1852. *Sean Pavone.*

THE UNITED STATES TREASURY
(1836–1842, ADDITIONS 1855–1869)

Architects: Robert Mills (East and Central Wings), Ammi B. Young and Alexander H. Bowman (South Wing), Isaiah Rogers (West Wing) and Alfred B. Mullett (North Wing)
Sculptor: James Earle Fraser

CIVIC VIRTUE

The Founders, Franklin, Madison, Hamilton, et alia, understood the link between classical civic behavior and Christian sentiment: "to discriminate the Spirit of Liberty from licentiousness—cherishing the first, avoiding the last" (George Washington on the obligations of citizenship). It is true in our republic, as once it was in the Roman Republic, that the accumulation of fine habits in personal living is necessary to civic success at home, in town, county, and state and, if industrious, if ambitious, the nation.

CIVIC ARCHITECTURE

Romans understood the indissoluble link between personal excellence and national greatness, that order and balance are requisite to stability, that there is a godlike magnificence when order and balance partake of scale and beauty. Vitruvius, in *De Architectura*, admits that the artistic-aesthetic and the

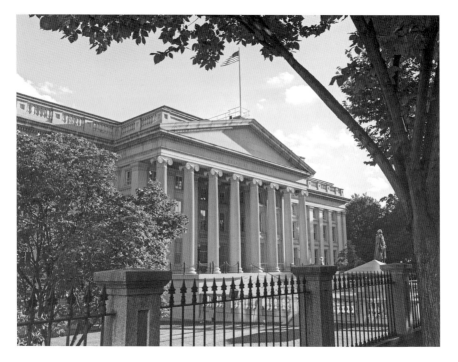

United States Treasury Building; Robert Mills, et alia, architects, 1836–1869. *Steven Heap.*

ethical-philosophical enshrine honor in physical form: Id est, material, style and use. We should note that modern, progressive buildings are not civic so much as they are functional: "civic" is that virtue of citizenship personified in architecture, commodious, familial, urbane, friendly; "functional" is that process of craft imposed by architects, utilitarian, habitual, systematic, impersonal. You have entered government buildings both classically civic and progressively functional, and certainly, you see, you feel, and you understand the distinctions.

TREASURIES

Aristotle in Book IV of the *Nicomachean Ethics* describes "magnificence" as an ethical virtue linked to money. We see in the great capitals of the world a classical magnificence in national treasuries: London, Berlin, Melbourne, et alibi. The first great treasuries are found in Olympia, Greece, and Robert Mills, architect of the United States Treasury, knew this, choosing the Greek

over the Roman form: here, the Ionic order of Athens' Erechtheion. Too, you will notice the low pitch of the Greek pediment, the balance of parts, confident stability, and beauty's reward on close inspection.

GREEK REVIVAL

Despite being republicans, Americans have always associated with Greek democracy, we—along with much of Europe—supported the Greeks in their battle of independence from the Ottoman Turks (1814–1832), we vote as did the Greeks and our culture is the continuation of Greek civilization. In architecture, the Greek Revival was encouraged by the fine work of archaeologist-architects who reimagined Greek architecture, as is seen in American towns of the early XIX Century where quaint, folksy interpretations of the Athenian Acropolis prettily nestle along the shores of midwestern lakes and rivers or stand solid and true on the vast, sweeping plains of America's heartland.

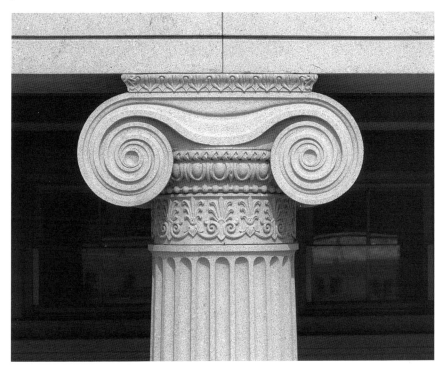

Robert Mills, Ionic capital, U.S. Treasury Building; ascended from the Ionic Order of the Erechtheion. *Carol M. Highsmith.*

CIVIC ALLEGORY

Abraham Gallatin (longest-serving secretary of the treasury, 1801– 14); James Earle Fraser, sculptor, 1947. *William Perry.*

Statuary has always been integral to classical architecture—pediments, friezes, niches, decoration—often in the form of female allegory. At the Treasury Building, there are two ideas of national economy represented in important secretaries of the Treasury: the Federalist polymath Alexander Hamilton, who established our national economic system, see him aristocratic, handsome, elegantly self-assured; then, Abraham Gallatin, the Jeffersonian democrat (Democrat-Republican Party) whose egalitarian practices limited presidential power, see him standing bold, feet firmly set in stubborn self-confidence. The very great sculptor James Earle Fraser tells more than do the secretaries' résumés, the stones of the building, or the "Treasury Act of Congress" the dual forces of our national economic debate—well, maybe, perhaps statues of Marx, Keynes, and Galbraith will be necessary to describe the recent generations of financial irresponsibility.

TOUR IV
THE LIBERTY STROLL

TOUR SITES

THE STATUES OF LAFAYETTE PARK

THE ALEXANDER HAMILTON STATUE

THE LAFAYETTE PARK NEIGHBORHOOD

NATIONAL, POLITICAL, AND PERSONAL LIBERTY

O urs is a story of independence and of liberty; of independence from coercion and indentures; of national liberty, liberty of the will and of the body; of economic liberty, a liberty without which emancipation is impossible. Many were the causes of the War of Independence from our mother country, England: colonial citizens rightly opposed the hard burdens of excessive, sometimes heedless taxation; the restrictions on commercial enterprise and trade; and the many English entanglements in slavery, with Indians and with foreign powers. Our nation's Founders were likely the most deeply educated Americans of any generation preceding and following. The Founders created from the close study of classics (in antiquity through the Enlightenment) a philosophy of government unprecedented in the history of the world, a government that, in the course of time, has matured to grant all Americans national, political, and personal liberty and that, by the undeniable force of a true philosophical axiom, is extending liberty to all who enjoy civil society: "We hold these truths to be self-evident, that all men are created equal, that they are endowed by their Creator with certain unalienable Rights, that among these are Life, Liberty, and the pursuit of Happiness.—That to secure these rights, Governments are instituted among Men, deriving their just powers from the consent of the governed."

Here, "Happiness" intends a species of *arête*, id est, "excellence."

LIBERTY

Liberty takes three forms, each form to scale: the national, the political, and the personal. Forms of liberty are seldom united; for instance, a nation may be free of foreign domination yet may contain slaves within its population; a population may choose political leaders yet be subject to control by government; a population may be at liberty yet may not vote for political representation. You will recognize in the preceding examples the Roman Empire, modern Communist states, and monarchies. These United States of America, more than any nation, combine national, political, and personal liberty.

NATIONAL LIBERTY

In these United States, national liberty was proclaimed in the Declaration of Independence on July 4, 1776 (see excerpt, above); national liberty was violently tested during the War of Independence, 1775 through 1783; national liberty was acknowledged by Great Britain in the Treaty of Paris, 1783; and thereafter was acknowledged by the great powers.

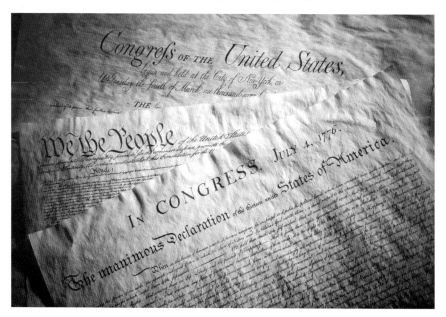

The Declaration of Independence, the United States Constitution and the Bill of Rights, three of the most important documents in world history. *Studio One Nine.*

POLITICAL LIBERTY

The Congress of the Confederation (1781–89) was inadequate to management of disparate interests of the several states; it was weak, disunited and quarrelsome; it was replaced by the Founding Fathers, who exceeded the mandate of amending the Articles of Confederation (1777) by drafting the Constitution of the United States (drafted, 1787; ratified, 1789), which in the original seven articles created the representative government that exists in this nation until the present time. The text of the Constitution begins with the preamble, "We, the people of the United States" and proceeds to delineate the manner of intergovernmental relations and the practice of political liberty.

PERSONAL LIBERTY

The Constitution in its original form provided justice, civility, and common defense, yet it did not contain provisions that would honor the personal liberties assumed in the Declaration, and for this, a Bill of Rights was necessary. The original ten articles of the Bill of Rights (1791) provided safeguards from the acknowledged tyranny of government, but these bills did not honor the Declaration's defining axiom; thus, a War to End Slavery was necessary to realize personal liberty for all Americans.

THE STATUE:
VIRTUE IN HUMAN FORM

Why remember the deeds, personalities, and lives of exemplary citizens: that we be improved by emulation, that we be inspired to virtuous action, that we be ambitious of the approbation of our fellow citizens for the good of ourselves and of the community. How do we remember exemplary citizens: by anecdotes, historical fictions, quotations, pictures and statuary. Anecdotes are telling; fictions amuse and instruct; quotations stick upon the mind; pictures capture a moment of life in the window of a frame; in statuary, the citizen abides among us and through us into the lives of our ascendants, ad infinitum. Who do we remember: We Americans remember our fellows who have achieved an illustrative reputation for virtue, virtue in utterance, virtue in civil accomplishment and in the deeds of battle. During this tour, we will visit the statues of men whose civic and martial virtues created national, political, and personal liberty in these United States.

The persons of the statues we shall visit represent foreign, aristocratic men who were drawn away from monarchical favor toward the honorable cause of enfranchisement in liberty; these men led we Americans to defense against the belligerent armies of England's King George III. Also, we shall visit the very great Alexander Hamilton, soldier, scholar, statesman, coauthor of the Federalist Papers, which delineated the manner of political liberty granted us through the Constitution. Later, in the epilogue, we shall visit those whose desire for liberty exceeded the expectations of rank and of policy, the lowliest among us, the slaves; they, more than any other, understood the meaning of liberty in the comportment of minds and in the composition of flesh, and with these Americans, we will conclude our book.

Statues

Statuary takes many forms. First, you should know that statuary exists in relation to architecture. A statue might be carved into a wall, as in ancient Egypt; a statue might rise in relief from a wall, in the manner of the coins in your pocket; a statue might be contained within the protection of an architectural feature such as a pediment; a statue might find its scale determined by an interior room or by a building from which it stands away; or, as in the statues of today's tour, the statue will stand atop its little bit of architecture, its characteristic base becoming a kind of building in itself, neighbor to other buildings or its own picturesque building within the park or landscape. Then, too, the character of the sculpted form is of a particular type, the ideal, the natural, the real, the abstract, each sculptural type resonating with the senses of our bodies that perceive aspects of reality we feel but seldom understand. I hope to help you understand the character of forms, how forms are resolved into ontologically physical ideas, and how by the senses, through perception, forms enter the body to become a part of you.

Noble Statuary

A statue is an idea made real; a noble statue is an ontological nobility, a nobility that each of us accepts into ourselves through the senses of our flesh; a statue lives as does a man yet in that higher plane of idea for which science has not yet invented a name. A man, a sculptor, a conscious idea in a statue lives in physical form and ineffable personality, and through the statue we live in the idea, the sculptor, the man, in that manner of life commonly understood before Roman Christianity, where within the statue resides the essence of the god, or of the hero, or, in the instance of Alexander, of both. This understanding of a statue's idea is among the many losses in the advance of scientific progressivism; here the denial of daimon, the genii, the genius, the soul, that incorporeal spirit which resides within the essence of a person from the moment of combined bodies (sperm and egg), through birth, from growth into death when the body comes into some other thing, becoming some other thing, releasing the genius, the soul to some other plane or place, who can say. Here, let us say "soul"; "daimon" is the Greek understanding, "genii" the Roman, "genius" the European, and soul is that conceptual understanding of human essence

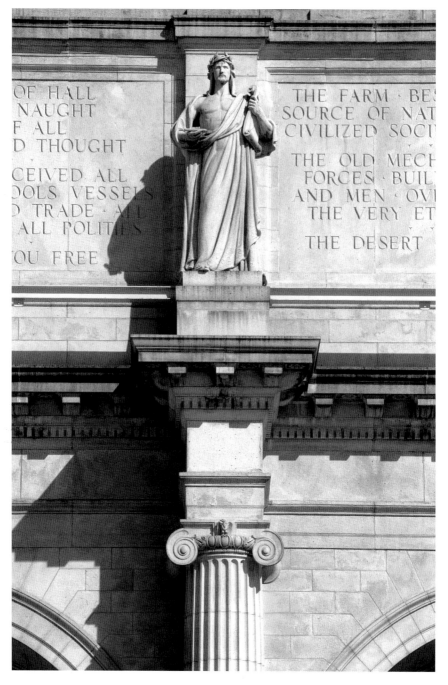

Themis, representing "Freedom and Justice"; Union Station, Louis Saint-Gaudens, sculptor, 1908. *Konstantin L.*

most commonly accepted as the explanation of sensibilities, ambulation and purpose, those corporeal powers by which the universe knows itself and through which the conscious soul understands the many facets of the omnipresent God, here, a spirit of nobility.

Once again, a statue is an ideal of a man made real, it is a thing different from sculpture, which might contain any idea large, small or insipid of anything or non-thing or nonsense; a statuary, the maker of statues, alike a minor deity, creates the idea of a man from what the conscious soul understands of the many facets of God active in the universe; a statuary cannot create more than he knows, nor can he imbue a statue with more than his wisdom understands or his hands have skill to execute. Now, a lovely truth, an axiom, alike a mathematical equation true at all times and in all places, "the universe knows itself through the mind of man." Id est, all persons understand from light through sensation in flesh the eternal, silent, universal qualities that are manifest in the statue; id est, the statuary understands nobility, through skill invests nobility into the statue, from the statue, through sensation by perception, nobility enters another man and another. The Greeks understood the power of imaged things entering the eye; be careful of what you see for it shall form what you become.

In brief: ideal forms cause our bodies to enter the harmony of eternal balance; natural forms engender sympathy with the composition of nature; real forms relax into commonplace happenstance; abstract forms reduce experience to base, animal comprehensions. Our bodies comprehend the forms of statuary before our minds discern the meaning, before our experience reveals a purpose. You will see in the statues we visit variations of idealism and naturalism. You will see how abstraction, in its proper place, in composition rather than in incompetent craftsmanship, directs attention to meaning. You will see the ideal balance from both idealism and naturalism in pose and arrangement of parts, and you will see by the movements within forms and between forms, alike the easy flow of rivers and the slow, sturdy growth of trees, all of nature distilled through a sculptor's mind into that still, sculpted, transcendent statuesque life that exceeds corporeal being. Here, we will not see the kitsch of realism, in the snapshot of a photographic accident or in the frozen moment of musical chairs. We will see excellent statuary well suited to the purpose of remembrance and the emulation of virtue. Of national styles, you will discover the differences between the French, the English, the International, and the American aesthetic. So then, let us visit the noble statues of today's tour.

THE STATUES OF LAFAYETTE PARK

Major General Marquis Gilbert de Lafayette (1891)
Architect: Paul Pujol
Sculptors: Jean Alexandre Joseph Falguière and Marius Jean Antonin Mercié

Other Statuary
Major Brigadier General Thaddeus Kosciuszko (1910)
Sculptor: Antoni Popiel
General Comte Jean de Rochambeau (1902)
Sculptor: J.J. Fernand Hamar
Major General Friedrich Wilhelm von Steuben (1910)
Sculptor: Albert Jagers
Major General Andrew Jackson (1853)
Sculptor: Clark Mills

REFINEMENT OF HUMAN FORM

When visiting the statues of Lafayette Park, you will notice the grace, the dignity, the classical beauty befitting the honor and accomplishment of our French, Polish, and German-American heroes. You will notice a refinement of human form alike the refinement of ideals in America's first classical age. You will notice how each statue is informed by three thousand years of principled virtues, of aesthetic excellence.

MARQUIS DE LAFAYETTE

Lafayette was a French-born aristocrat, general in the War of Independence and friend to George Washington. Also, Lafayette was in France a commissioned officer at thirteen, a wounded American veteran at nineteen, the American leader of troops against Cornwallis at twenty-four, the coauthor (with Jefferson) of the *Declaration of the Rights of Man and the Citizen* and, in the same year of the French Revolution (1789), acclaimed commander-in-chief of the National Guard of France. He was later imprisoned by the French and by the Austrians; released by Napoleon I, in whose government he refused to participate; retired (alike Washington) to his farm; and returned to tour the United States by invitation of President Monroe. Back in France at sixty-eight, he declined the offer to become dictator of France. At seventy-five, he participated in the June Rebellion (see Hugo's *Les Misérables*), and Lafayette died at seventy-six, buried in Paris beneath soil from Bunker Hill. Worth noting is the Marquis' social

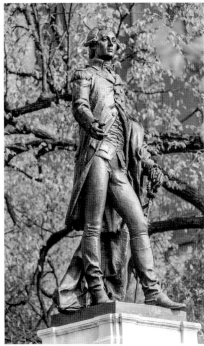

Major General Marquis Gilbert de Lafayette; Paul Pujol, architect; Falguière and Mercié, sculptors, 1891. *William Perry.*

experiment proposed to Washington, in which land would be purchased where slaves could work as free tenants. Washington, though enthusiastic, demurred. Lafayette purchased 125,000 acres with plans to emancipate the diverse slaves, but the seizure of his property by the contemptible French Revolutionary Guard foiled this noble intention.

GENERAL THADDEUS KOSCIUSZKO

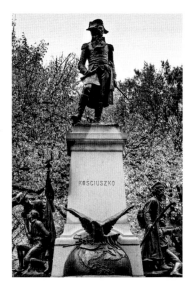

Major Brigadier General Thaddeus Kosciuszko; Antoni Popiel, sculptor, 1910. *William Perry.*

Kosciuszko was a Polish military engineer and volunteer in service to Benjamin Franklin before his great accomplishments of military architecture (state-of-the-art fortifications, including West Point) that resulted in the honorary title of brigadier general. Kosciuszko returned to Poland, where he was appointed major general of the Polish–Lithuanian Commonwealth army, whose intent was to win national liberty from Russia; his defeat and capture by Russia ended in Poland's 123-year subjugation. When, in 1796, Kosciuszko was pardoned by Tsar Paul I, he returned to the United States, reestablished his friendship with Thomas Jefferson (with whom he shared ideals of liberty) and, with Jefferson's assistance, once again entered the complex battle for republican liberty in the Napoleonic Wars. Yet the tide of European monarchical history opposed him, and he failed to win Polish national liberty from either Tsar Paul or Napoleon. In a final act of republican defiance, the ailing general emancipated his serfs from the land, an emancipation that was denied by the tsar. Upon Kosciuszko's death (1817), the church bells rang throughout a subjugated Poland. Kosciuszko left in his will funds and provision to free and educate American slaves, including slaves bound to Jefferson, yet the will was denied, despite three times being favorably considered by the United States Supreme Court, his Polish relatives prevailing in their nation's court. The Kosciuszko Mound in Kraków, Poland, is truly and rightly counted among the largest monuments in the world.

COMTE JEAN DE ROCHAMBEAU

Rochambeau was a French nobleman and commander-in-chief of the French Expeditionary Force, a force larger than that commanded by General Washington. Following the Siege of Yorktown, Rochambeau joined with Lafayette to force the surrender of Cornwallis. Returning to France, in quick secession, Rochambeau was honored by Louis XVI; was commissioned commander of the French revolutionary army; was imprisoned by the French revolutionaries; narrowly escaped the guillotine; was pensioned by Emperor Napoleon I; retired to his estate, where he self-consciously mirrored the retirement of the admired George Washington; and died along with the dream of liberty at the dawn of the Napoleonic, First French Empire.

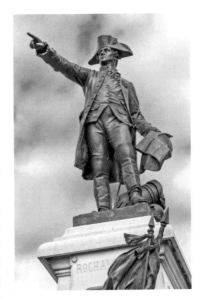

General Comte Jean de Rochambeau; J.J. Fernand Hamar, sculptor, 1902. *William Perry.*

WILHELM VON STEUBEN

Steuben was the Prussian-born inspector general of the Continental army, Washington's chief of staff, a major general and the author of *Regulations for the Order and Discipline of the Troops of the United States*. Wilhelm von Steuben became a naturalized America citizen who, in the American fashion, retired to his log cabin on military pensioned land in the woods of New York.

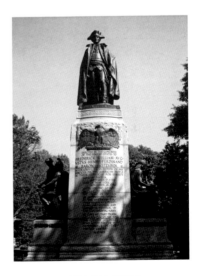

Major General Friedrich Wilhelm von Steuben; Albert Jagers, sculptor, 1910. *AgnosticPreachersKid.*

THE ALEXANDER HAMILTON
STATUE (1923)

Architect: Henry Bacon
Sculptor: James Earle Fraser

UNIVERSAL LIBERTY

The military heroes remembered in the statuary of Lafayette Park were foreign men inspired by the high ideals of liberty. Each hero, in his way, served the essentially human cause of liberty in America and in his native land; each found success in America; and each hero who returned to his homeland ended life in passive retirement after martial efforts to extend liberty failed. Why did Lafayette, Kosciuszko and Rochambeau fail? Are all people by education, inclination, and nature suited to accept the responsibility of personal liberty? The answer to this question is found in the history of the world, "No." Our Founding Fathers understood the tendency of government to tyranny, of interest to avarice, of men to blood. Two quotes here must serve as example: Franklin in response to the question of what was given us in the Constitution, "A Republic, Madame, if you can keep it"; Jefferson on a wise and frugal government which "shall restrain men from injuring one another, shall leave them otherwise free to regulate their own pursuits of industry and improvement, and shall not take from the mouth of labor the bread it has earned."

You have seen in the liberty statues recently visited an intelligence of noble qualities; you have witnessed the ascent of civilization in many

national realizations: the French full, harmonious eloquence of Falguière in Lafayette, the Polish earthy earnestness of Popiel in Kosciuszko, the last flowering of French heroic gesture in Hamar's Rochambeau and in Jaegers you have seen Steuben, a sturdy, measured, disciplined Germanic American. Feel these bodies, if you will, learn the story and take into yourself, alike virtuous food, the eternal essences, and you will extend the purpose of civic statuary, you will increase the span of our nation's life, as has Alexander Hamilton, the man, the intellect, the statue.

ALEXANDER HAMILTON

Hamilton, where to begin? An accomplished poet at fourteen (the equal of Alexander Pope at the same age); at eighteen he raised and led a company of sixty soldiers to fight in the War of Independence; from twenty to twenty-four he was Washington's chief of staff; congressman at twenty-five; he founded the Bank of New York at twenty-seven; a delegate to the Constitutional Convention and coauthor of the Federalist Papers at thirty; at thirty-two, as secretary of the treasury, he established the National Bank, the U.S. Mint, et cetera and et cetera; he was murdered by his former law partner, the vice president of the United States, Aaron Burr, in a duel at Weehawken, New Jersey. I agree with George Will, who claims that we honor Washington and Jefferson with monuments but that we live in Hamilton's monument (these United States), and with Talleyrand, who said, "I consider Napoleon, Fox, and Hamilton, the three greatest men of our epoch, and if I were forced to decide between the three, I would give without hesitation the first place to Hamilton." And one more instance of Hamilton's foresight, pertinent to that third instance of liberty that follows national liberty and political liberty, that liberty given to us by Hamilton, et alia, personal liberty; in this instance, his lifelong opposition to slavery and his understanding that the War of Independence was inseparable from abolition: briefly, his polemic against England's establishment of slavery in continental America, his opposition to the Three-Fifths Constitutional Compromise, his presidency of the Manumission Society that ended slavery in New York and his plan for the formation of a unit of freed slaves in the Continental army.

Standing before Hamilton the statue, we have the opportunity to match words to shape, to the man himself. Here, handsome, as in life he was; beautifully composed of aesthetic form true to the harmony of intellect; keen, intelligent of design by the hand of the sculptor and the God of Nature;

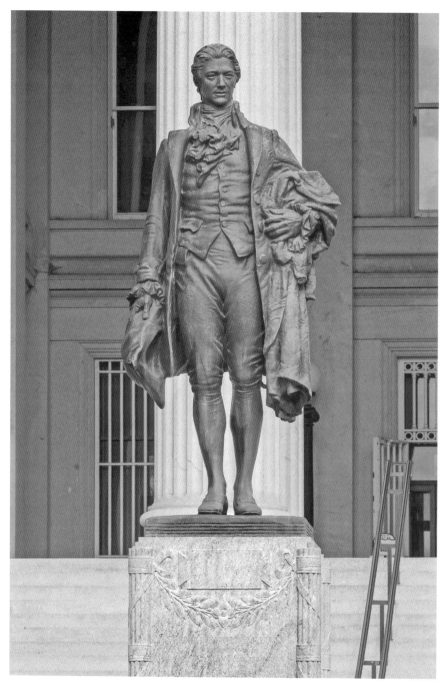

Alexander Hamilton; Henry Bacon, architect; James Earle Fraser, sculptor, 1923. *William Perry.*

fashionable, as he is and as he was; confident, at ease, energetic, strong; a soldier, notice the pulsing, gripping strength of the hands, notice the breeze, the living fabric freely ruffled, the undulating strength, the potentiality of action, the suggestion of virility, the shoe's edge barely restrained, just breaking the plain of cushioned plinth and all that suggests. J.E. Fraser was a sculptor tutored by masters and was a master of craft, exemplar of the art. Now, listen, hear in these few phrases Hamilton, the man himself; return to that time that has borne our own in liberty:

> *There is a certain enthusiasm in liberty that makes human nature rise above itself, in acts of bravery and heroism.*

> *Real liberty is neither found in despotism or the extremes of democracy, but in moderate governments.*

> *The sacred rights of mankind are not to be rummaged for among old parchments or musty records. They are written, as with a sunbeam, in the whole volume of human nature, by the hand of the divinity itself; and can never be erased.*

> *Of those men who have overturned the liberties of republics, the greatest number have begun their career by paying an obsequious court to the people, commencing demagogues and ending tyrants.*

> *In framing a government which is to be administered by men over men, the great difficulty lies in this: you must first enable the government to control the governed; and in the next place, oblige it to control itself.*

> *I never expect to see a perfect work from an imperfect man.*

The preceding quotes we find, mostly, in the Federalist Papers, that collection of essays necessary to the ratification of the United States Constitution, essays formative of American identity, political opinion and civic virtue.

THE LAFAYETTE PARK NEIGHBORHOOD

Heroes of Liberty

Other founder statues in the broad neighborhood of Lafayette Park include Lieutenant General George Washington, Benjamin Franklin, Major General Nathanael Greene, Captain Nathan Hale, John Paul Jones, Commodore John Barry, Dr. John Witherspoon, General Casimir Pulaski and General Artemas Ward. You will notice that these statues were created in the classical idiom of the nation's founding, that they are noble in bearing, that they inspire emulation, and that they enrich the city in beauty, in meaning, and in purpose.

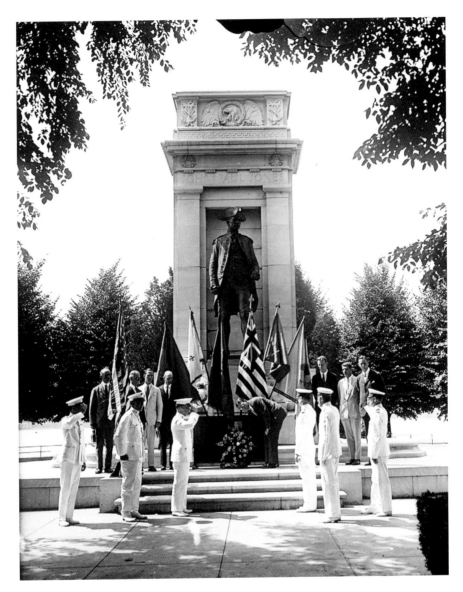

John Paul Jones Memorial; Charles H. Niehaus, sculptor, 1912. *Harris & Ewing.*

TOUR V
HONORING HEROES

TOUR SITES

THE LINCOLN MEMORIAL

THE VIETNAM WAR VETERANS MEMORIAL

THE KOREAN WAR VETERANS MEMORIAL

THE NATIONAL WORLD WAR II MEMORIAL

FREEDOM AND SACRIFICE

T here is nothing inherently sacred in the western end of the National Mall; it is high land created by Americans from mosquito-infested swamps. The meaning of this land is that which we give it: We give this place meaning in the remembrance of citizen sacrifice in the struggle for freedom. The Lincoln Memorial, the World War II Memorial, the Korean War Veterans Memorial, and the Vietnam War Veterans Memorial each concern a particular sacrifice for freedom: the Lincoln Memorial, for the freedom of American slaves, the sacrifice of 750,000 men in the War to End Slavery, including the sacrifice of President Lincoln himself, among the last to die in the war; the World War II Memorial, for the freedom of all the world, even those citizens of the Axis Powers (Germany, Italy, Japan), the sacrifice of 405,000; the Korean War Veterans Memorial, for the freedom of Koreans from communist conquest, the sacrifice of 37,000; the Vietnam War Veterans Memorial, for the freedom of the Vietnamese from communist adventurism, the sacrifice of 58,000 dear, beloved souls.

In quantitative reading, we lose meaning in accumulated numbers. In the consideration before us, to more fully understand the nature of, the experience of ultimate sacrifice, let us, in familiar horror, see in our own mind's eye that last vision through the soldier's eye, the blood and the slaughter, the field, tree and sky, the moment of final, painful, labored breath so that we, in the most humane, sincere sympathy, might feel some measure of what was lost in that ending moment of life. And now, let us consider the purpose that compelled the soldier's personal sacrifice in the cause of freedom, in the extension of freedom to family, to friends, to those who might be strange in

habit, separated by distance and custom but familiar in humanity, in love and in hope. From Lincoln at Gettysburg:

> *It is for us the living, rather, to be dedicated here to the unfinished work which they who fought here have thus far so nobly advanced. It is rather for us to be here dedicated to the great task remaining before us—that from these honored dead we take increased devotion to that cause for which they gave the last full measure of devotion—that we here highly resolve that these dead shall not have died in vain—that this nation, under God, shall have a new birth of freedom—and that government of the people, by the people, for the people, shall not perish from the earth.*

FREEDOM AND LIBERTY

> *The freedom which we enjoy in our government extends also to our ordinary life. There, far from exercising a jealous surveillance over each other, we do not feel called upon to be angry with our neighbor for doing what he likes....*
> *We throw open our capital to the world, and never by alien acts exclude foreigners from any opportunity of learning or observing, although the eyes of an enemy may occasionally profit by our liberality; trusting less in system and policy than to the native spirit of our citizens; while in education, where our rivals from their very cradles by a painful discipline seek after manliness, at Athens we live exactly as we please, and yet are just as ready to encounter every legitimate danger.*
> —*Thucydides, in the voice of Pericles, funeral oration for Athenians fallen in battle against Sparta,* History of the Peloponnesian War

Note: From this same speech we read, "If we look to the laws, they afford equal justice to all in their private differences," the origin of our concept "equal justice under law."

The evolution of freedom is traced in the development of Greek words for liberty, the etymology of which would be exceedingly onerous here; instead, a telling gloss upon freedom's conceptual development in classical Western Civilization. The notion of freedom was not born in the realization that freedom is a possession but in the realization that this thing, "freedom" (liberty, independence, *eleutheria*), could be lost in submission to Asiatic Persia (circa 479 BC), and this anticipated loss extended freedom's comprehension

through courts, assembly, property and in most every civic arena where freedom might have opportunity to supplement its meaning and where, through Plato and others who distrusted the will of the people, often for good cause, that freedom encountered its first restrictions. The Delian League was that political construction formed to oppose foreign Persian tyranny in rule, customs, manners, and language; this league was also, in the cause of freedom, the source of the Athenian Empire, an empire that broadly extended native Athenian democracy, sometimes by force. Athenians understood that democracy, although not synonymous with freedom, was antagonistic to oligarchy in all its many forms. This Athenian antagonism toward Persian and Spartan oligarchy was inherited by Alexander, who, in the defeat of Persia, liberated Hellas (Greece) and extended Hellenism from India through Carthage into Rome, and all the while freedom continued to augment, supplement, refine and distil into unique expressions. The Romans created rights and privileges of citizenship; Cynics found happiness in freedom from possessions, manners and passions; Christians expressed freedom in conscience and in an immortal soul free of status, of sin and of death; Europeans realized freedom as release from the land and its overlords; and passing on, we Americans presume freedom to pursue those industries of virtue and improvement that bring material, spiritual, and familial happiness. You will have noticed that each acquisition of freedom occasioned some species of war, cultural, national, or personal.

WARS FOR LIBERTY

The time is now at hand which will probably determine if Americans are to be freemen or slaves. The fate of unknown millions will now depend, under God, on the courage and conduct of this army.
—*George Washington*

It is a fact proven in deed that freedom is achieved by victory in war, that freedom is lost by defeat in war. Peace does not occasion freedom; the repose in victory occasions peace: "Those who expect to reap the blessing of freedom must, like men, undergo the fatigue of supporting it," according to Thomas Paine. We have witnessed the development of freedom through resistance, victory and personal virtue; here, on land raised from a swamp, at the sunset of our capital's border, is found the spiritual resting place of those Americans who sacrificed their lives for our freedom.

THE LINCOLN MEMORIAL

(1914–1922)

Architect: Henry Bacon
Sculptors: Daniel Chester French and Evelyn Beatrice Longman
Painter: Jules Guérin

PARTISAN POLITICS

When, in 1902, the McMillan commissioners proposed a memorial to Lincoln at the National Mall's western border, the obstacle most daunting was the commemorative highway, a form of Appian Way from Washington through the memorial grounds to Gettysburg. Highway advocates observed that a classical building was inappropriate for a prairie president, considering his pants rather than his disposition of mind, I suppose. Not everyone favors the classical Beaux Arts (beautiful arts), as not everyone favored the Emancipation Proclamation; Republicans accused Democrats of being partisans who would make a highway to divert attention from the Republican Lincoln and to redirect attention to the popular soldiers, and then, the burgeoning highway industry and eager automobile manufacturers, with eagle perception, recognized in seventy miles of roads the opportunity for profit. The debate continued: Democrats broadcast base motives for Lincoln's temple, staining Republicans as cruel representatives of the socially elite, "cold, heartless marble" and "hurling the nation's memory into pagan darkness" were by stiff-backed Democrats

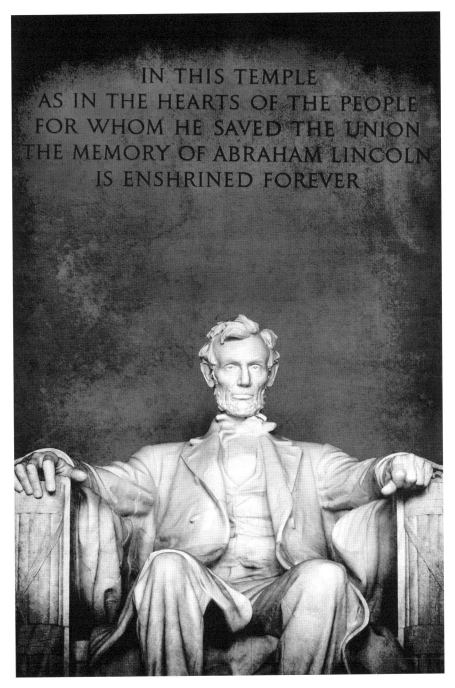

Abraham Lincoln; Daniel Chester French, sculptor, 1922. *Lane Erickson.*

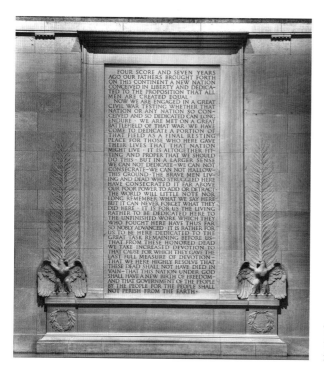

The Gettysburg Address,
the Lincoln Memorial,
interior. *Adam Parent.*

expostulated in the House of Congress. One confused congressman, Joe Cannon [R], vowed that never would he allow a monument to Lincoln in "that Goddamned swamp." Congressmen bluster, candidates pose, industry lobbies and, occasionally, reason prevails: The Lincoln Memorial bill passed.

A SUITABLE SITE

The Lincoln Memorial continues to annoy naysayers by being the most popular and least elite of the capital's memorials. Remoteness of the site has not deterred eager citizens, and the beautifully classical design has ennobled all activities that occur within it and around it. John Hay, secretary to Lincoln, observed the strength of the site:

> *As I understand it, the place of honor is on the main axis of the [McMillan] plan. Lincoln of all Americans next to Washington deserves this place of honor. He was of the immortals. You must not approach too close to the immortals. His monument should stand alone, remote from the*

common habitations of man, apart from the business and turmoil of the city; isolated, distinguished, and serene. Of all the sites, this one, near the Potomac, is most suited to the purpose.

It seems that, after all, a building in classical taste is appropriate for a heroic statue, a great president, and an epoch-defining war.

CLASSICAL ARCHITECTURE, RULE AND INVENTION

The model for the Lincoln Memorial is the Athenian Parthenon, yet Henry Bacon did not make a slavish copy, nor did he depict scenic American history, nor did he decorate the temple in that ostentatious manner of the Romans; instead, Bacon dilated on America's reconstruction, Abraham Lincoln, his force and accomplishments, id est, on greatness, national union, and the end of slavery. Following rules, inventing from need, Bacon encompassed the memorial with thirty-six columns, each column representing a battling state of the war, and then, instead of doodads in the attic metopes, the states are named (above, thirty-six from 1865; below, twelve from 1922 to construction), and here, uniquely open at the side, we will enter. The interior is equally inventive under rule: tripartite rooms, the center described in symbolic murals flanking the span; where statuary should be found, the votive, the Lincoln statue open to the people, addressing Washington and Congress rather than secreted under inner chambers. Let us approach Daniel Chester French's heroic Lincoln statue along this stately ascent, through the steadfast columns, past the wisdom of home-spun speeches to stand beneath the potent gaze of an American hero.

THE VIETNAM WAR
VETERANS MEMORIAL (1982)

Designer: Maya Lin
Sculptor: Frederick Hart

SIMPLICITY

War memorials offer little interpretation, and this one is simply spare: two glossy black walls join together in bare black arms that point toward the Lincoln Memorial and the Washington Monument; upon the arms, a counted list of names of those who died in service to their country. You might assume that this chronological list of names would begin at the left and proceed to the war's ending on the right, but no, to find the name of family or friend look to the center, where beginning and end names meet, then move to one end or to the other (I cannot say which) to recognize and recall the particular serviceperson. Two inscriptions are found on the wall:

> *1959 In honor of the men and women of the Armed Forces of the United States who served in the Vietnam War. The names of those who gave their lives and of those who remain missing are inscribed in the order they were taken from us.*

> *1975 Our nation honors the courage, sacrifice and devotion to duty and country of its Vietnam veterans. This memorial was built with contributions from the American people.*

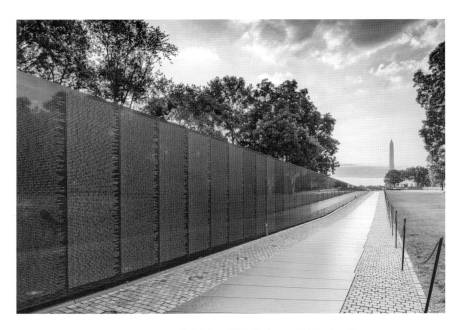

The Vietnam War Veterans Memorial; Maya Lin, designer, 1982. *Sean Pavone.*

Again, entering the memorial from whichever way, right or left, one is in the middle of the war leaning forward in progression to the war's ending or leaning backward in progression to the war's beginning, both of which meet at the memorial's center. When exiting the memorial, to right or to left, one is in the mid- to late 1960s, and here are seventy black panels of names that taper to a final, short panel of three names each, each name almost following along as you depart. In post-modern allusion, many references come to mind, yet here I think it best to allow the artist, Maya Lin, to speak for herself:

> *When I was building the Vietnam Memorial, I never once asked the veterans what it was like in the war, because from my point of view, you don't pry into other people's business.*
>
> *The process I go through in the art and the architecture, I actually want it to be almost childlike. Sometimes I think it's magical.*
>
> *It was a requirement by the veterans to list the 57,000 names. We're reaching a time that we'll acknowledge the individual in a war on a national level.*

A QUIET PLACE

For visitors, especially those for whom there is a particular cause of remembrance, this memorial can be powerful in pause and in contemplation. Alike a wound, Lin designed an open scar in the ground. This open wound has served as an amphitheater for memorial services on Veterans Day and Memorial Day. As wounds are in themselves incapable of understanding, purpose and healing, Frederick Hart was commissioned to create the fashionable, typically race-conscious *Three Soldiers* statue group, which, in a realistic war-weary snapshot, represents a Caucasian-American, a West African–American and a Hispanic-American.

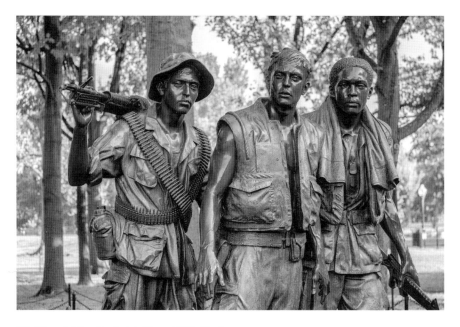

The Three Soldiers; Frederick Hart, 1982. *Kamira.*

THE KOREAN WAR VETERANS MEMORIAL (1995)

Architect: Cooper-Lecky Architects
Sculptor: Frank Gaylord

THE FORGOTTEN WAR

There were no homecoming parades for veterans of Vietnam, nor were there homecoming parades for Korean War veterans, nor a tickertape Wall Street parade, nor a Grand Review along Pennsylvania Avenue; there is only the necessary, pedestrian-like acknowledgement of the Korean War veteran after the style of the fashionable Vietnam War Veterans Memorial.

INVENTING MEMORIALS

The Korean memorial differs from the Vietnam memorial, although it was obviously designed in Lin's simplistic aesthetic. The black granite wall of the Korean War Veterans Memorial pictures etched faces instead of etched names. Lin-like, the slick black wall barricades a flank of landscape crafted to imitate Korean mountains. Slouching into the memorial precinct are nineteen bulking statues of American servicemen that slosh over granite curbs, rocky soil and artless shrubbery intending to mimic Korea's dikes and marshes; these nineteen soldier-statues are in post-modern fashion

The Korean War Veterans Memorial; Cooper-Lecky Architects, 1995. *Orhan Cam.*

mirrored in the granite wall mountain to equal thirty-eight—you are expected, unprompted, to note the hint of the thirty-eighth parallel, which divides the Koreas. And then, in modernistic insignificance, the soldiers form a triangle that juts into the reflecting pool kind of as the Korean peninsula juts into the sea. The gray stainless steel statues are a tad over seven feet high; the didactic plaque on the side wall states, "Dedicated July 27, 1995. Architects Cooper-Lecky. Frank C. Gaylord, sculptor." The monument's designers, long on explanation, short on budget and schedule, imposed upon Frank Gaylord an unkind and unenviable task. Across the walkway, to the soldiers' left, the casualties of the conflict are numerically etched into a low wall.

THE STATUES

The statues' rough portraits include every branch of the armed forces and, very likely, every DNA racial group variant. Trudging alongside the soldiers into the front, one arrives at the American flag to focus on the point-man (he most likely to be shot). A scolding plaque at the foot of the flag reads, "This

memorial honors those who gave their lives for a land they had not seen and for a people they did not know." Against the wall is another commonplace plaque: "Freedom is not Free."

THE FOOT SOLDIER

This routine memorial intends a direct statement of sacrifice and freedom. Although we admit that this memorial is not a great work of art, we acknowledge that artists and architects of this time seldom achieve greatness. The Lincoln Memorial is great; the Korean and Vietnam Memorials serve a kind of purpose toward a species of national reconciliation—Vietnam for the counterculture, Korea for the veterans. The Washington Monument did not require a tableau of Continental army soldiers standing ground against redcoats; the Lincoln Memorial did not need pictures of the First Minnesota plugging the gap at Gettysburg; if the World War II Memorial wants the Battle of the Bulge, I should not say; yet here, for veterans of the Korean War, is a monument neither in apology nor in triumph, an egalitarian memorial, an encomium to the common soldier. You will notice that Korea, with Vietnam, unnecessarily balances the symbolic force of the Lincoln Memorial and clutters the symbolic force of the memorial ground, that essential national meaning from the Capitol Building through the Washington Monument to the Lincoln Memorial, with the White House and the Jefferson Memorial on the fulcrum. These icons are the essence of national identity.

ADDENDUM

Rather near the Korean War Veterans Memorial, along the placid shore of the Tidal Basin, are two memorials necessary to our national narrative, illustrative of progressive storylines: the Franklin Delano Roosevelt Memorial and the Martin Luther King Jr. Memorial. The Roosevelt, in pedantic pastiche and a rote of quotable quotes, seeks to entertain as it instructs and puts one in mind of a bronze and granite carnival with curious sideshows and barking advertisements; you will find in the merriment children petting the bronze dog and people splashing in the pools and groups in mock solemnity queuing up behind the breadline, and there will be teachers leading choruses of quote repetitions, and you are likely to catch, as have

I, naughty boys and girls in exercise climbing about and in target practice tossing bits of stuff at choice subjects. The memorial is an entertaining success, a quotable reminder ("The only thing we have to fear is fear itself") and a lesson in progressivism whose final quotations add to the Bill of Rights two freedoms not comprehended in that document; perhaps you can identify them: "Freedom of speech…Freedom of worship…Freedom from want… Freedom from fear."

Dr. Martin Luther King Jr., as I have no need of telling you, was a clergyman and prominent civil rights leader who continued the Jeffersonian tradition expressed in the self-evident truth of our 1776 Declaration of Independence, "that all men are created equal, that they are endowed by their Creator with certain unalienable Rights, that among these are Life, Liberty, and the pursuit of Happiness." The Martin Luther King Jr. Memorial was instigated by fellow members of Dr. King's college fraternity, Alpha Phi Alpha, a fraternity whose classical precedents are, alike most all things classical, compelling, potent and predictive. Here: *Alpha*, the first letter in the Greek alphabet (*beta*, the second, i.e., *alpha-beta* = a-b-cs, the alphabet). And here: *Phi*, "the twenty-first letter in the Greek alphabet, a letter whose speaking constricts sound." Now, say "ph" (of phi) and you shall hear and you shall see and you might, perhaps, understand the meaning of this fraternity whose icon is the Great Sphinx of Giza, whose aim is "manly deeds, scholarship, and love for all mankind," and then the telling of the antiquated-archaeological, political-religious, and hopeful motto should be obvious: "First of All, Servants of All, We Shall Transcend All."

It seems here appropriate to mention *paideia*, the Athenian practice of education, of learning culture through the liberal, mechanical, and physical arts (literature, mathematics, gymnastics, et cetera). Paideia is Western Civilization's model for molding a human animal into a cultured citizen: for ancient Athenians, the *kalos kagathos*, the beautiful and good man; for medieval Catholics, the knight, the chivalrous Christian warrior; for enlightened Europeans and Americans, the gentleman, the chivalrous, courteous, honorable man. You will notice how through the hammer and anvil of history, by the potter's clay of culture, a man like Dr. King is formed into an exemplary warrior who, in manly resolve, without resort to violence, fulfills the Creator's purpose in demonstrating that all men are created equal, that all have equal right to the endowment of Nature's God: life, liberty, and the pursuit of virtuous excellence.

The quotations on the memorial, chosen by a panel of progressive politicians, activists, and academics, have less force in reading than in

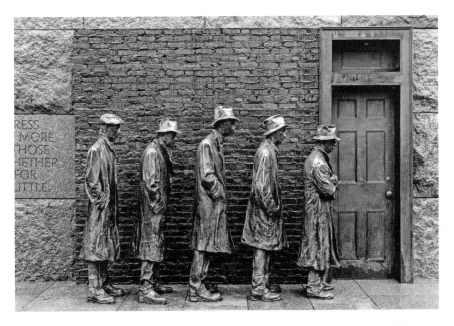

Room 2, *Breadline*, Franklin Delano Roosevelt Memorial; George Segal, sculptor, 1997. *Tinnaporn Sathapornnanont.*

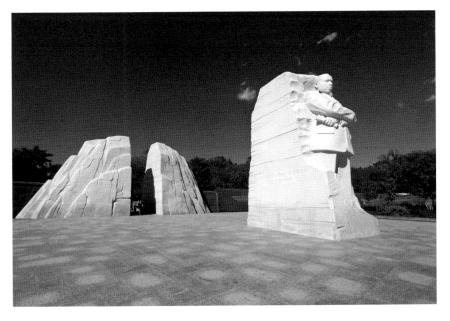

Martian Luther King Jr; the Martin Luther King Jr. Memorial; Lei Yixin, designer, 2011. *kropic1.*

address and concern justice, democracy, hope, and love, and curiously, they do not include even a phrase from his "I Have a Dream" speech, which was King's penultimate cause of national fame. Then, it is a shame that this great American, in the mold of great Americans, was modeled in China by a Chinese sculptor who was tutored in the adulation of dictators, who was trained to create images that over-awe, whose specialty is mammoth statues of the murderous communist leader Chairman Mao, and this is why our great American, in pose, in attitude, and in feature, appears rather more the dictator, rather less the wise, brave, and gentle man who helped extend a promise of our Declaration of Independence. Significantly, I must observe that this progressive state memorial to the Reverend Dr. Martin Luther King Jr. expunges all references to the God whom the reverend served.

THE NATIONAL WORLD WAR II MEMORIAL (2004)

Architect: Friedrich St. Florian
Sculptor: Ray Kaskey

PREFACE

In departing from the L'Enfant and McMillan traditions, iconoclastic progressives have altered, have damaged, perhaps irreparably, the meaning of the capital city and the purpose of national identity. Allow me to explain. Modern art begins in vanity, those libertine excesses celebrated in bohemian adventure and debauchery. Modern philosophy begins in absurdity, that fantastical ghost (*zeitgeist*, time's phantasm) that controls humans alike puppets on a string, nations alike leaves in the breeze. Modern bureaucracy begins in tyranny, the process of taking from one what he has achieved to give to one who is in need. Progressivism begins in belief, the faith that applied science can create a perfect state. Yet humans are fallible, science incomplete, bureaucracy unwieldy, and artists are, well, not what they could be. Art, philosophy, bureaucracy, and hubristic faith have formed a bunion upon that hinge of culture that articulates nations and feeds civilization.

DESIGN COMPETITIONS

Where to begin: From the founding until World War I, politicians, artists, and the people were one in loyalty to those bedrock principles of beauty, goodness, and truth. Our aesthetic divisions began with government control of the arts inspired by Franklin Delano Roosevelt's Works Progress Administration, which, after World War II, led to the Great Society's National Endowment for the Arts (NEA), an endowment that, in practice and in purpose, rewards progressivist art and punishes classical art. Today, by administrative plan, the NEA extends the federal government into state arts councils and through state arts councils into a percentage of tax funds designated for art in public buildings, lately, to city arts councils, where "art-in-public-places" mandates are administered by consultants, chosen by competitions that favor progressive art. And this is why you find curious baubles, bright-bent metal and insulting irony in greeting at city, county, state and federal buildings.

Here, in our nation's capital, the process of choice in design and designers for "public works" is managed by layer upon layer of bureaucratic agencies, each bureaucracy staffed by progressives fundamental, functional or passive. A few of these agencies are the National Capitol Advisory Memorial Commission, the General Services Administration, the National Parks Service, the National Capitol Planning Commission, the Commission of Fine Arts, and others, and each new memorial or monument concept (progressive, classical, traditional or kooky) must enter into the mouth of each agency, twisting, bending to the will and requirements of each agency, one after the other until the memorial concept comes out the other end a thoroughly vetted, thoroughly transformed, thoroughly approved statement of the progressive aesthetic.

WORLD WAR II MEMORIAL DESIGN

The selection was made, the architect was chosen. Friedrich St. Florian is a competent modernist, considerate, polite, eager to address the concern of fellow progressives of government agencies; in truth, an artist of sorts, sensitive, ambitious of creating a memorial rich in meaning, full in descriptive content. The sculptor, Ray Kaskey, who understands monumentality, narrative description and composition, was an excellent choice. Scholars of the memorial will recognize the shadow-shape of Olmsted's "Rainbow

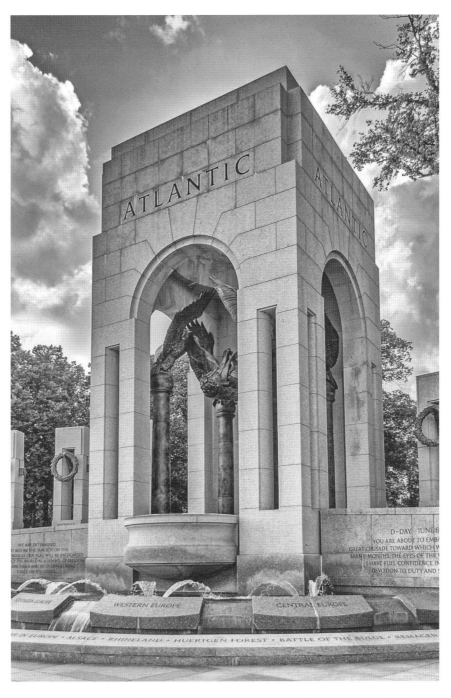

The Atlantic baldacchino; Friedrich St. Florian, architect; Ray Kaskey, sculptor, 2004.
Marco Rubino.

Pool"; the baldacchino "triumphal arches" inspired by Lutyens' "Thiepval Memorial" (whose listing of names informed Maya Lin's Vietnam Veterans Memorial); the fifty-six wreathed pillars representing American states and territories; the "Killroy was here" engravings (as though etched into granite by mercurial GIs); the gruesome and triumphal narrative friezes picturing the progress of war; and the Freedom Wall, the "Field of Stars" remembering that gold star presented to mothers whose sons died in battle, each star here representing one hundred soldiers who died in the war, the dear, priceless cost of victory for freedom.

CRITICISM

Many were the critics of the memorial: the preservationists, who liked things just as they were; the civil libertarians, who opposed inscriptions implying Judeo-Christian values; and the academic modernists, who in bow ties, round glasses, and sharp pencils caricatured the classicalish design as "Mussolini fascism," "freezing and embalming" and "copying period styles," as though modernism, ecoism, deconstructivism, constructivism, expressionism, internationalism, brutalism, technoism, post-modernism, et cetera are not old-fashioned period styles. The more accurate criticism concerns the inarticulate use of classical, architectural language in the columns, distributed weight in the balance of parts and proportion in detail, all of which are mastered by apprentices in classics, all of which are fumbled by accomplished progressives. Yet here, in the World War II Memorial, the style, though imperfect, is sympathetic to its surrounding, considerate of its landscape, stately, properly respectful of its occasion and suitable to the honor of those Americans who sacrificed themselves, their lives, for the freedom of the world.

WORLD WAR II

No activity of tribe, of clan, of city or of nation more fully tests communal will, more specifically demands civic excellence, more completely requires universal mobilization than does war. No single activity creates history more than does war. War extinguishes languages, manners, religions; war establishes empires, ideas, civilizations. A few wars have created freedom, and these most often in battles little larger than a football field. Think of

wars that extinguished civilizations: the Mycenaean defeat of Troy (circa 1250 BC, likely, Troy VI); Sultan Mehmed's conquest of Constantinople, which in AD 1453 ended the Roman Empire; the defeat of the Aztec by the Spanish coalition, 1521, et cetera. Battles of the great wars for freedom have created or preserved all persons who are reading these words: the battles of Thermopylae, Marathon and Salamis, of Granicus, Issus and Gaugamela, of Tours and Vienna, et cetera; yet the war that included more battles upon which depended freedom, not merely of cities, states, and nations but of all persons living, was World War II, that war that consolidated human history and formed a human family united in the heritage of freedom. Yes, true, communism for a time expanded, tribalism persisted, theocracies festered, yet the Anglo-American Alliance, we inheritors of liberty's principles, the civilization most directly ascended from classical freedom in government and civic tradition, triumphed in the test of wills, liberty against tyranny; in civic excellence, aspiration against obedience; in universal mobilization, cooperation against compulsion. Liberty once again proved itself culturally superior to obedience. The common foot soldier, that boy who became a man by honoring our nation's Founders, placing his hand to his heart in the Pledge of Allegiance, who faithfully worshiped the God of Nature and of the Bible, he, his English brethren and sympathetic others accomplished victory in the Second World War and won, by personal sacrifice, a new birth of freedom for all the world. For this we remember heroes, for this we honor tradition, for this we build memorials suitable to principles, persons, and occasions.

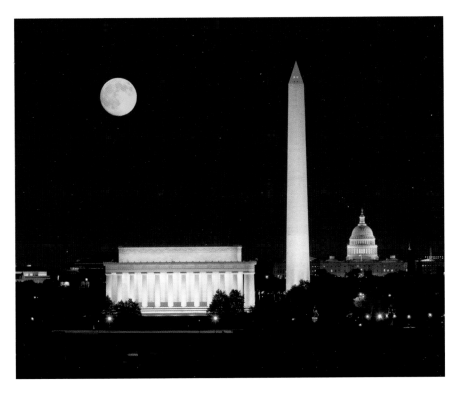

Harvest moon illuminating the District of Columbia. *Steven Heap.*

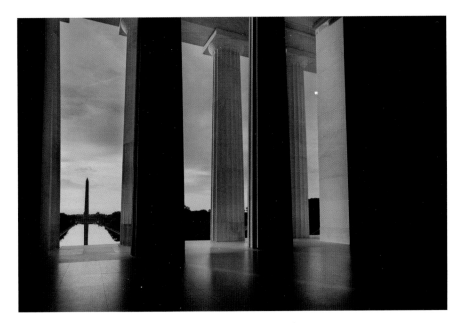

The Classical City. *Sauseyphotos.*

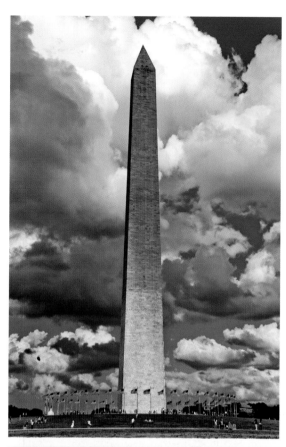

Left: The Washington Monument; Robert Mills, architect, 1848–84. *Jon Bilous.*

Below: The Jefferson Memorial, John Russell Pope, architect, 1943. *Adam Parent.*

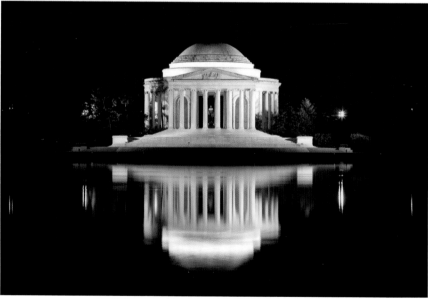

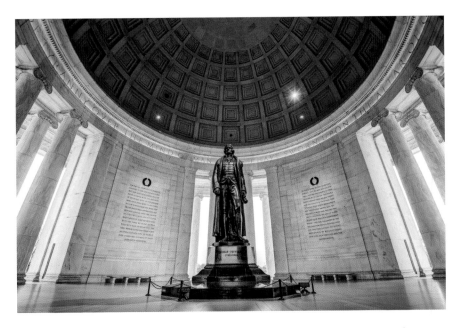

The Jefferson Memorial, interior; John Russell Pope, architect; Rudulph Evans, sculptor, 1943. *Sean Pavone.*

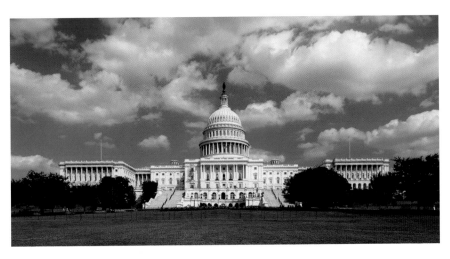

United States Capitol Building, East Front; William Thorton, et alia, architects. *Martin Falbisoner.*

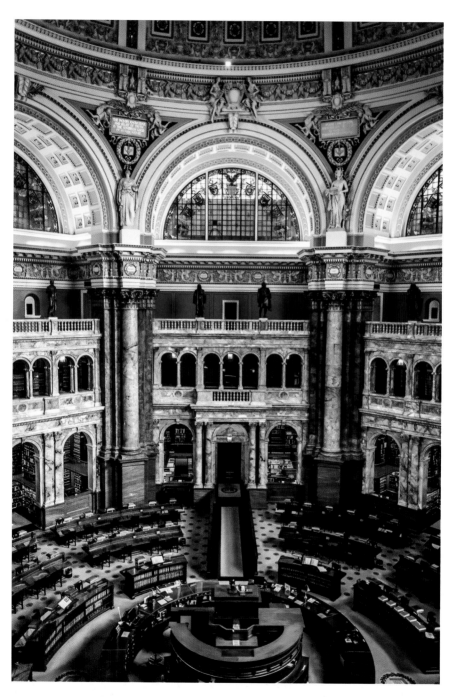

The Library of Congress, Jefferson Building, Reading Room. *John Bilous.*

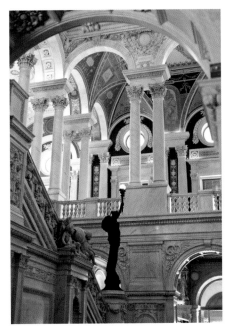 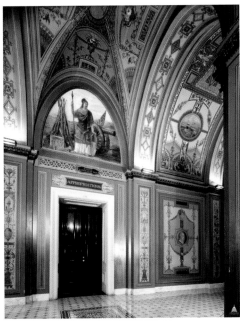

Left: The exquisite interior of the Library of Congress, Jefferson Building. *Steven Heap.*

Right: Lunette, *Bellona the Roman Goddess of War*, entrance to the Military Affairs Committee room (former); Constantino Brumidi, frescoes, 1850–65. *Architect of the Capitol.*

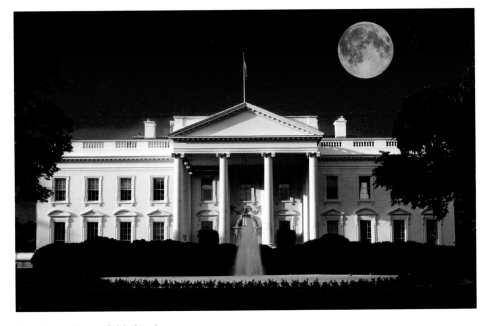

The White House. *Spiritofamerica.*

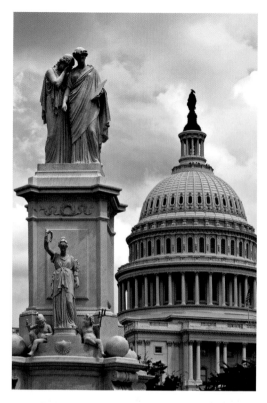

Peace Monument; Franklin Simmons, sculptor, 1876. *Curtis.*

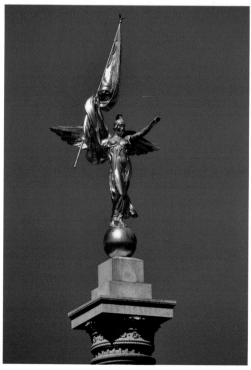

First Division Monument, President's Park; Cass Gilbert, architect; Daniel Chester French, sculptor, 1924. *Lee Snider Photo Images.*

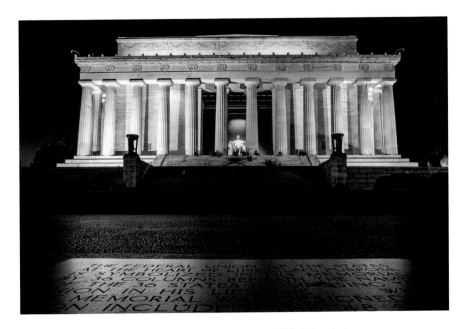

The Lincoln Memorial; Henry Bacon, architect, 1922. *Valerii Iavtushenko.*

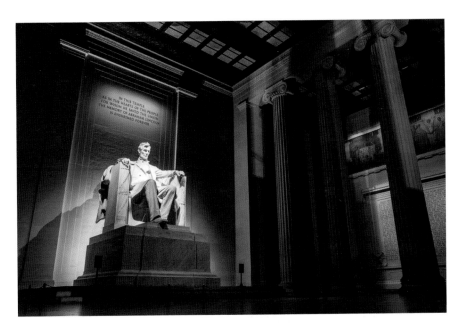

Abraham Lincoln; Daniel Chester French, sculptor, 1922. *Viii.*

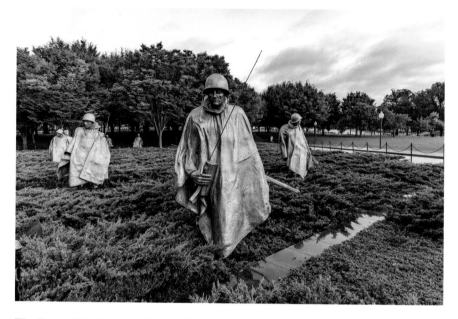

The Korean War Veterans Memorial; Frank Gaylord, sculptor, 1995. *Png Studio Photography.*

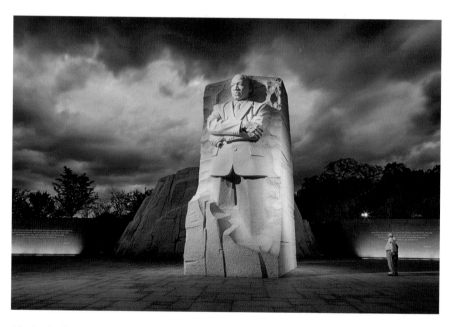

Martian Luther King Jr; the Martin Luther King Jr. Memorial; Lei Yixin, designer, 2011. *kropic1.*

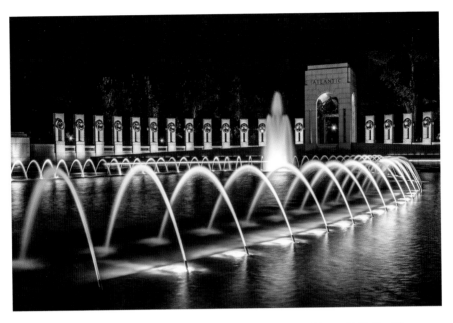

The National World War II Memorial; Friedrich St. Florian, architect, 2004. *Jon Bilous.*

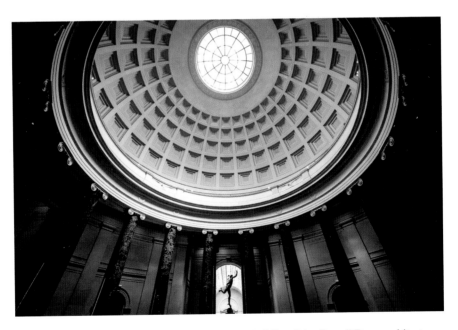

The interior dome, National Gallery of Art, West Building; John Russell Pope, architect, 1941. *Jon Bilous.*

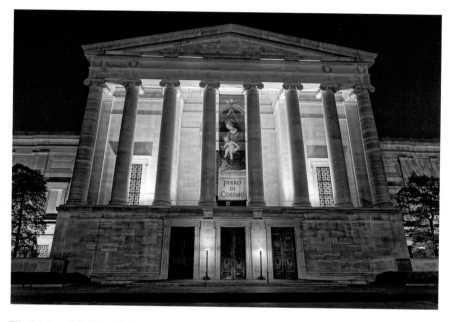

The National Gallery of Art, West Building; John Russell Pope, architect, 1941. *Roman Babakin.*

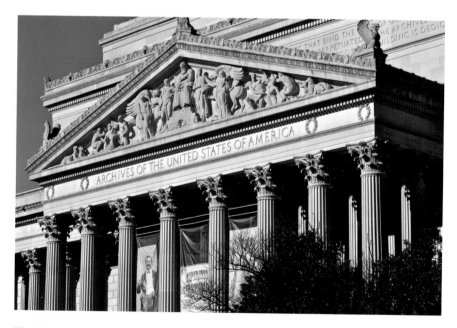

The National Archives Building; John Russell Pope, architect; James Earle Fraser, et alia, sculptor, 1935. *Jeramey Lende.*

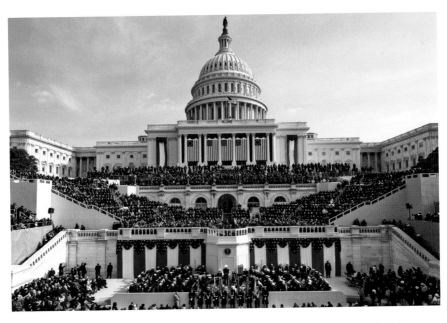

New Troy: looking up the hill to the United States Capitol Building; inauguration, 2009. *Architect of the Capitol.*

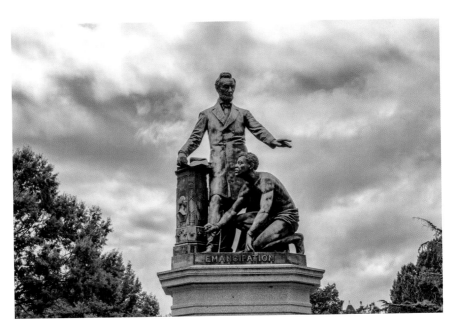

The Emancipation Memorial, Lincoln Park; Thomas Ball, sculptor, 1876. *Valerii Iavtushenko.*

Left: The Gail Kern Paster Reading Room, Folger Shakespeare Library; Paul Phillipe Cret, architect, 1932. *Folger Shakespeare Library, Julie Ainsworth.*

Below: Union Station; Daniel Burnham, architect; Louis Saint-Gaudens, sculptor, 1908. *Andrei Medvedev.*

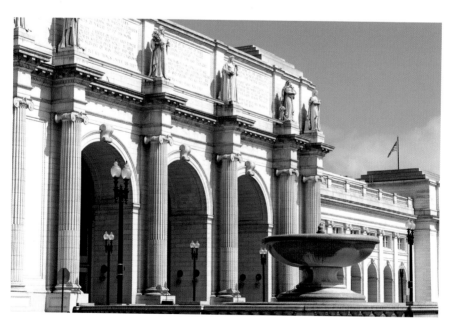

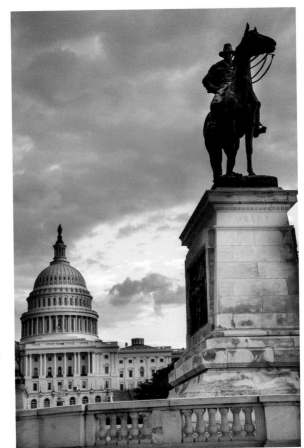

Right: Ulysses S. Grant Memorial; Henry Merwin Schrady, sculptor and architect, 1924. *William Perry.*

Below: Civil War Unknowns Monument, Arlington National Cemetery; Montgomery Meigs, architect, 1865; redesigned in 1893 to resemble the Ark of the Covenant. *Adam Parent.*

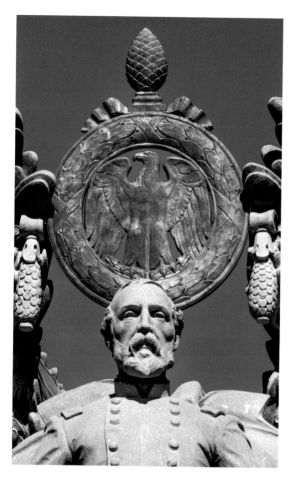

Left: The George Gordon Meade Memorial, General Meade (detail); Charles Grafly, sculptor, 1927. *William Perry.*

Below: Department of Labor Building (currently the U.S. Environmental Protection Agency); Arthur Brown Jr., architect, 1934. *Jon Bilous.*

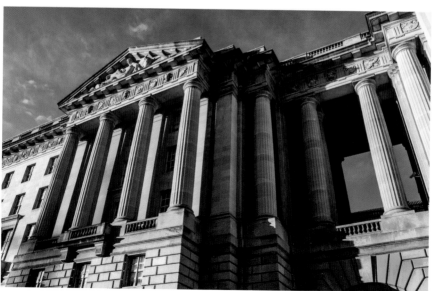

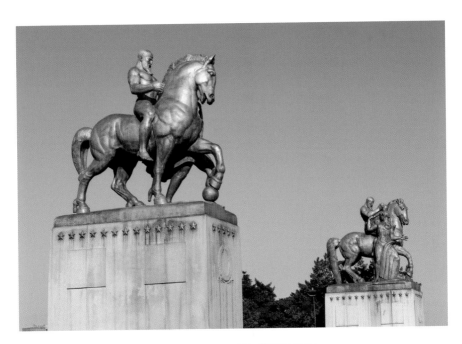

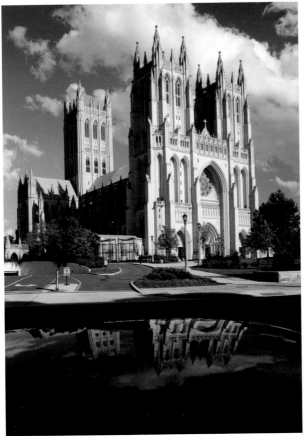

Above: "The Arts of War," *Valor* (*left*), *Sacrifice* (*right*); Leo Friedlander, sculptor, 1925, installed, 1951. *Orhan Cam.*

Left: Cathedral Church of Saint Peter and Saint Paul, "Washington National Cathedral" (Gothic style); Bodley, Frohman, architects; Hart, Carpenter, Harlow, et alia, 1907–90. *Steven Heap.*

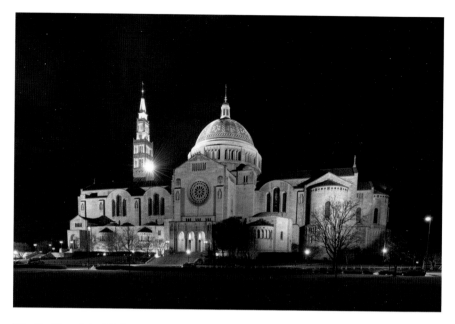

The Basilica of the National Shrine of the Immaculate Conception (Byzantine Romanesque style); Maginnis & Walsh, architects, 1920–61. *Stanislav Sergeev.*

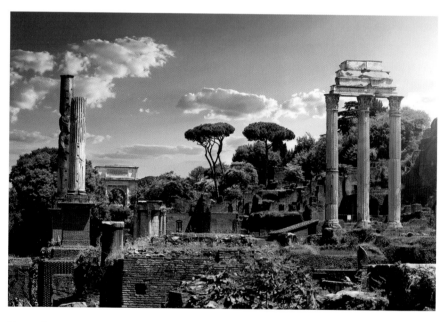

Forum Romanum: the God of Nature reclaims all the works of man. *Givaga.*

TOUR VI
THE FEDERAL TRIANGLE

TOUR SITES

THE NATIONAL GALLERY OF ART, WEST BUILDING

THE NATIONAL ARCHIVES

THE HERBERT C. HOOVER DEPARTMENT OF COMMERCE BUILDING

SYMBOLS OF EMPIRE

PREFACE

The objects of today's tour are buildings that contain the inheritance, the history, and the activity of a nation. Each building is uniquely suited to its purpose. Buildings well conceived are, alike a person, a body suited to the purpose of its existence. If well conceived and well executed, the body serves the function of its existence; if not, it fails—as we shall see in the example of the National Gallery of Art, East Building.

AN AMERICAN EMPIRE

Chicago's 1893 World's Columbian Exposition demonstrated to the world that Americans were prepared to assume the leadership of Western Civilization in commerce, in culture, and in the arts. The classical form and the imperial scale of the exposition was the origin of America's City Beautiful Movement. The assembly of American civic artists who perfected their craft in this first grand and beautiful exposition, and in expositions previous to pedantic scientific progressivism (Building the World of Tomorrow, 1939, New York City, et cetera), achieved an art suitable to an American empire formed to extend liberty.

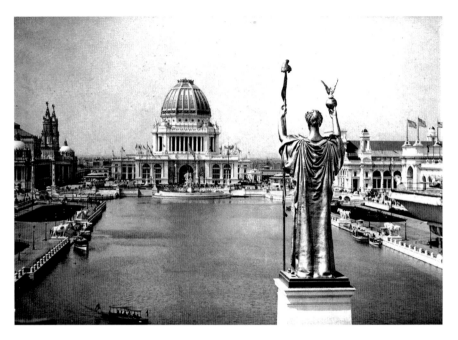

Looking from the Peristyle, over the Grand Basin to the Court of Honor; the World's Columbian Exposition, 1893. *CD Arnold.*

Administrative State

The founding documents created a people who created an empire of liberty. New institutions and bureaucracies were required by the expanding administrative state. Republican and Democrat progressivist presidents presided over a building program of a scale remarkable in human history. Theodore Roosevelt, Woodrow Wilson, Herbert Hoover, and especially Andrew Mellon commissioned and facilitated great works of civic art.

Inherited Stewardship

Alike the Pantheon of the Roman gods, the National Gallery of Art, West Building, is a pantheon of Western Civilization's artistic genius. XX-Century Americans inherited the Romantic idea of the artist's divine inspiration, and it was assumed that the artist, alike the hero, deserved to dwell with the muses ("museum" from "*museo*," a "home for the muses").

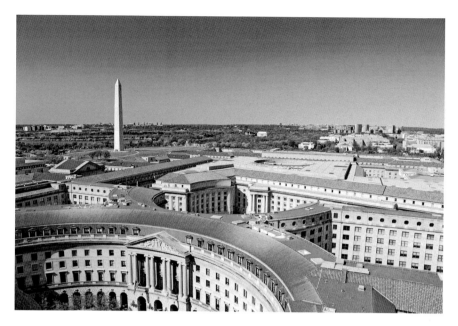

Aerial view of the Federal Triangle (constructed 1927–98), that group of imperial buildings constructed to house the administrative state. *Songquan Deng.*

Further, it was understood that citizens would be uplifted in partaking of the beautiful and the divine. Yes, perhaps. The National Gallery of Art is also a guarded treasure box within which America holds in trust Western Civilization's riches.

CONSTITUTION OF EMPIRE

The documents of Liberty are safeguarded in the National Archives Building. We shall see how this building, alike the Ark of the Covenant, protects the liberty of humanity. A primary business of Plato's Academy and of Aristotle's Lyceum was the creation of constitutions for Greek city-states, because the Greeks understood, as do we, that a constitution forms a people—I am fond of saying that all places at all times are melting pots, most everyone comes from some other place; all people from all places are the children of immigrants; America is made great by the Constitution which forms us into a single people, a people united in the conviction that we are endowed by our Creator with life, with liberty,

and with freedom to pursue excellence. The documents of Liberty (Magna Carta, Declaration, Constitution, Bill of Rights) have formed we Americans and the modern world.

MANAGED ECONOMY

The Department of Commerce was formed of the progressivist belief that scientific management of economies is superior to economic liberty. The Department of Commerce Building is named for the longest-serving secretary of commerce, Herbert C. Hoover, thirty-first U.S. president.

THE NATIONAL GALLERY OF ART, WEST BUILDING (1936–1941)

Architect: John Russell Pope

PRECEDENT

The National Gallery of Art (NGA) West Building is the beautiful, finely articulated building next to the plain, blank, flat NGA East Building (discussed at the end of this section). Invention within tradition is among the strengths in the practice of classical architecture. In the instance of the National Gallery, Pope employed the virtues of the Pantheon in the closed rather than in the open form that he employed in the Jefferson Memorial. The open form invites citizens to participate in Jefferson's democratic, republican principles; the closed form contains the precious riches of Western Civilization.

EXTERIOR

This tripartite temple is similar in plan to the United States Capitol Building yet thirty-one feet longer. You will notice the difference between the exuberant, sometimes fussy details of the Capitol and the Gallery's exquisitely conceived delineation in the system of ordinance (panels, architraves, pilasters, moldings), and then you will notice that the Gallery's dome is restrained by rational geometry while the Capitol's dome is

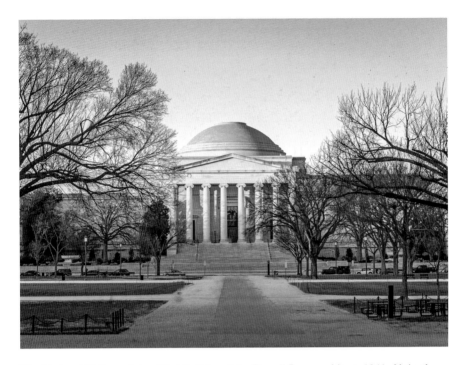

The National Gallery of Art, West Building; John Russell Pope, architect, 1941. *National Gallery of Art.*

uninhibited by the insufficiently massed building below. Less obvious will be the balance of weight in the subtle gradation of dark to light in the Gallery's Tennessee marble, a unique aesthetic pleasure when seen in rain.

INTERIOR

Sixteen thirty-six-foot-high green marble columns support the rotunda at the Gallery's main entrance; you will notice the dramatic effect of light in the rotunda's oculus and the effect of artificial, diffused light on the art and on the articulated walls throughout the galleries. To stroll through the progression of galleries is to enjoy a history of architecture. Each room is a unique experience crafted to embody the essence of a historical period.

The Renaissance rooms, National Gallery of Art, West Building; John Russell Pope, architect, 1941. *Anton Ivanov.*

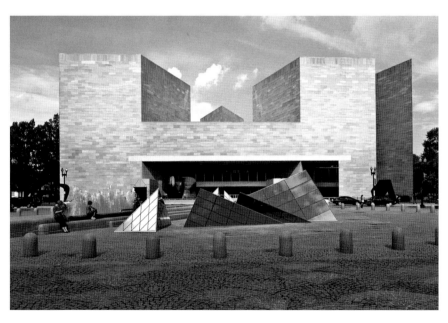

National Gallery of Art, East Building; I.M. Pei, architect, 1978. *Joerg Hackmann.*

SYMPATHY

To compare Pope's West Building to I.M. Pei's East Building is to compare reason to rationalization. The West Building is responsible to America's classical tradition, to art, to we the people and to our posterity; it lends beauty to the city and engenders remembrance of the good, the beautiful, and the true; it provides an interior easy to navigate, intimate yet spacious; it is commodious to visitors; it offers contextual sympathy to works of art on liberally provided walls; and its traditional masonry construction answers the test of time. Conversely, the East Building is the peculiar idea of one man; its gigantic walls block the landscape, offering no relief and little aesthetic pleasure (excepting the trick-of-the-eye view down diverging walls); it is directionless—better suited to the wandering of bugs than to human purpose—and the sideways stairs cause inconvenient confrontations in crooked stepping; its galleries are little larger than peeping closets, while its big open space is suitable for showing nothing; and its experimental construction method failed, as so often progressivist experiments do—there is a reason buildings have been constructed as they have been for these four thousand years—to the cost in repair of $83 million a few decades after opening.

THE NATIONAL ARCHIVES
(1931–1935)

Architect: John Russell Pope
Sculptors: James Earle Fraser and Adolph Alexander Weinman; also Robert Aiken, Laura G. Fraser, Sidney Waugh, et alia

THE NATIONAL ARCHIVES

The Archives Building preserves and protects historical records of the American people and of the federal government, including the census, acts of Congress, presidential proclamations, executive orders and votes of electors. Central to the Archives Building's purpose is the safeguard of documents formative of the American people: the Declaration of Independence, the Constitution and the Bill of Rights. You will also find here three other documents necessary to the extension of liberty: the Northwest Ordinance, the Louisiana Purchase Treaty, and the Emancipation Proclamation. Another document sacred to all free people is preserved in our archives, the Magna Carta Libertatum (the Great Charter of the Liberties of England), which, for colonial Englishmen in British America, was the precedent for enjoyment of liberties assumed by citizens of the mother country, a liberty enshrined in our Constitution's Fifth Amendment: "no person shall be deprived of life, liberty, or property, without due process of law."

NATIONAL ARCHIVES BUILDING

Official government papers refer to the National Archives Building as a temple of history, which it is in both character and design. Early designs of the Archives Building make visual reference to architecture of the ancient Levant and of Egypt, the ziggurat and King Solomon's Temple; Pope's later design is stronger, more monumental, better composed than the earlier, derivative concept, and you will notice that the boldly original Archives Building's central treasure chest swells, that it expands, explodes the surrounding Roman temple, which cannot constrain the essential documents of liberty, the Declaration, the Constitution, the Bill of Rights, those documents that are treasured within this expansive, ark-like monument. Among the many virtues of classical design is the conversation within tradition, a conversation that we architects have with architects of three thousand years ago, with classical architects three thousand years into our future, a conversation in the language of architecture where an Ark of the Covenant might illuminate the meaning of an Ark of Liberty.

PEDIMENTS

Symbolic pediments are found at the Constitution Avenue (south) and Pennsylvania Avenue (north) entrances to the Archives. To the south, the "Destiny" pediment created by Adolph Alexander Weinman (designer of the "Liberty Head" dime) includes the powerful, central allegorical male *Destiny* flanked by many statues, including *Arts of Peace and War*, *History*, *Romance*, and the *Guardians of the Secrets of the Archives*. To the north, the "Recorder of the Archives" pediment created by James Earle Fraser (designer of the "Indian Head" nickel) includes a Roman patriarchal *Recorder* seated on a Greek klismos chair (a more elegant Greek style of our European dining chair) who is flanked by symbolic statues who gather, who collect, who record and who protect historical records and sacred documents; additionally, this pediment features allegories of *Pegasus* for "inspiration," dogs for "guardianship," rams for "parchment," et cetera. Fraser's team also designed the medallions of government, the eagle acroterion and other embellishments. On the day the pediment ensemble was completed, an exuberant Laura Fraser wrote, "Amen!"

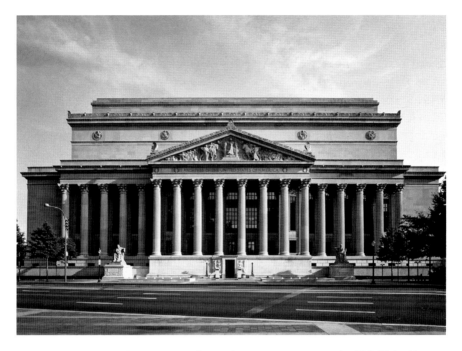

The National Archives Building; John Russell Pope, architect, 1935. *Carol M. Highsmith.*

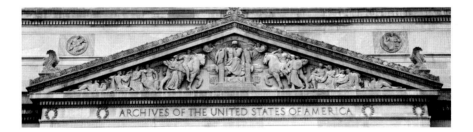

The Recorder of the Archives pediment; James Earle Fraser, et alia, sculptor, 1935. *M. Dogan.*

INSCRIPTIONS

This text gives all too little attention to inscriptions, those ideas hard carved in stone, the character, the content, and the consideration contained in chains of words, words that bind conceptions to a people, to a time and to a place. The words that we remember form our morals, shape our character, mold our personality; the Bible, *Mein Kampf*, the Declaration, *The Communist Manifesto*, and those insipid rock-and-roll lines everywhere piped

into our heads make of us a kind of person, a people, a civilization with distinguishing or disgusting qualities; epigraphers, historians, philosophers find conclusions in definitive phrases that tell of who we were, who we are, of what we might become.

That time between the great wars was stern, often severe, requiring a strict loyalty to American liberty, to our essential goodness and moral strength; much value is contained within the walls of the Archives Building, little noticed is the virile, the potent epigraphs that were hard carved in the bones of the building and inscribed in the minds of Americans during that desperately serious, sincere time of our history. On the Sidney Waugh–modeled Fraser design of the *Guardianship* statue is carved ETERNAL VIGILENCE

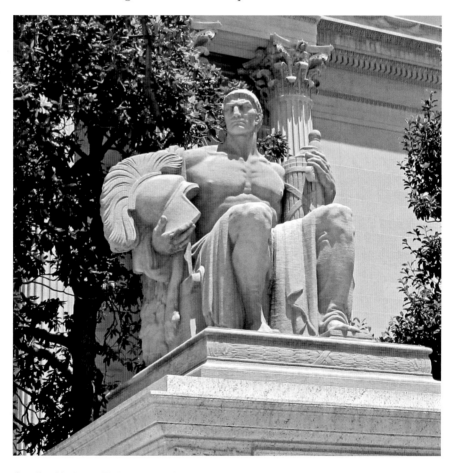

Guardianship; James Earle Fraser & Sidney Waugh, sculptors, 1935. *Emkaplin.*

IS THE PRICE OF LIBERTY; on the David Rubens–modeled Fraser design of the *Heritage* statue is carved THE HERITAGE OF THE PAST IS THE SEED THAT BRINGS FORTH THE FUTURE. The force and majesty of these inscriptions, on these statues, demonstrate the resolve of a burgeoning American empire and tell why James Earle Fraser has been named the "Sculptor of Empire"—that and his friendship with the great President Theodore Roosevelt. *Note: These statues were at the time of their creation the largest carved from a single block—a special rail-track was needed to bring *Guardianship* and *Heritage* to the National Archives Building.

THE HERBERT C. HOOVER DEPARTMENT OF COMMERCE BUILDING (1927–1932)

Architect: York and Sawyer
Sculptors: Designer. James Earle Fraser; Executors. U. Ricci, H. Pattigan, F. Roth, J. Kiselewski, et alia

THE FEDERAL TRIANGLE

The Federal Triangle is that group of early Progressive-era buildings bordered by the Ellipse, Pennsylvania and Constitution Avenues. Originally seven in number, the buildings housed both traditional government and progressively expanding bureaucracies, including Archives, Post Office, Justice, General Accounting, Internal Revenue, Labor, and Interstate Commerce. (The District Building and the Old Post Office predate the Federal Triangle and are not typically included; the International Trade Center, Ronald Reagan Building is now included among the FT buildings.)

THE ADMINISTRATIVE STATE

Various government agencies determined that the growing administrative state should be located between the White House and the Capitol in the Roaring Twenties neighborhood of criminals and prostitutes to the east of the White House. After this neighborhood was demolished, the

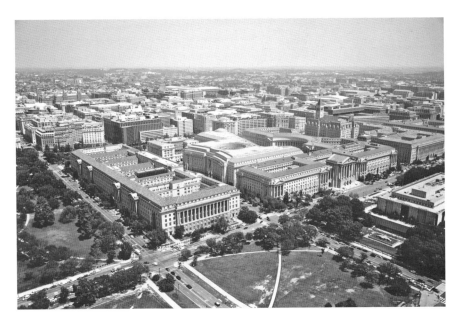

A portion of the Federal Triangle and its symbiotic buildings; constructed 1927–98.
Wangkun Jia.

administrative buildings of the commonly known "Louvre Plan" could begin (the Louvre-Tuileries Palace incorporates the administrative buildings of the French monarchy).

THE HERBERT C. HOOVER BUILDING

The building that houses the Department of Commerce is remarkable for its magnitude. On eight acres, it covers three city blocks that contain (at its opening) over 1.8 million square feet of floor area; 3,300 rooms joined by unbroken corridors 1,000 feet long; a Great Hall approximately half a football field in plan; and it was at the time of completion the largest office building in the world. In this latter feature it joins other Washington, D.C. landmarks that have been the world's largest: the Washington Monument (tallest until the Eiffel Tower) and the Pentagon (currently the largest office building in the world).

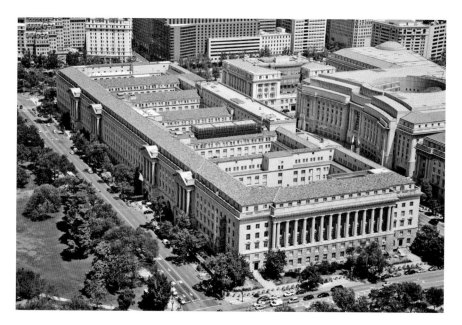

The Herbert C. Hoover Building; York and Sawyer, architects, 1932. *Wangkun Jia.*

FEDERAL CLASSICISM

A form of muscular classicism, much in the Roman manner, born in the international Beaux Arts movement yet mediated by American architects with the correct restraint of civil republicanism, federal classicism is distinguished in academic precision and artistic good taste. You will notice the magnificent scale, fine drawing and excellent proportions in the civic arts of American federal classicism.

SYMBOLISM

The four muscular pediments seem to be a manner of heroic, imperial labor that transforms to a purpose earth, sea, and air: *Mining, Fisheries, Aeronautics,* and *Foreign and Domestic Commerce*; the three pairs of panelized doors are also peopled by symbolic representations of heroic labor. The imagery here is remarkably similar to state-controlled art of the many fascist countries of progressively elite Europe. (See the Stadio Municipale Benito Mussolini, the Olympia-Stadion, Berlin, et cetera.)

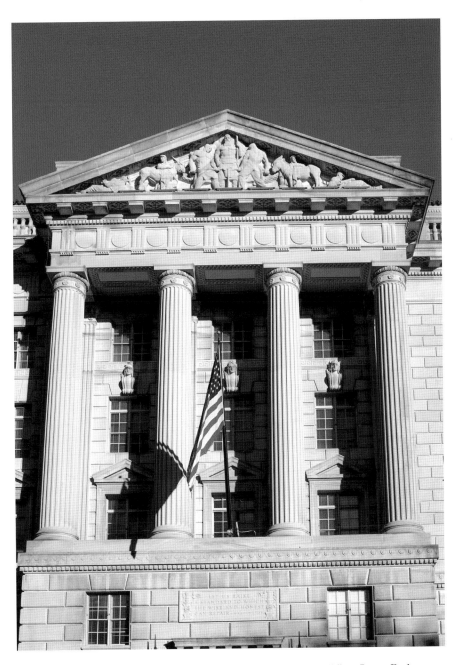

Mining pediment; Herbert C. Hoover Building, U.S. Commerce Building; James Earle Fraser, sculptor, 1932. *Orhan Cam.*

SCULPTORS

Throughout the XIX Century, American sculptors were trained in the grand academies and master ateliers of Europe. Beginning at the 1893 World's Columbian Exposition and continuing through the 1915 Panama-California Exposition, American sculptors were increasingly taught in America by American sculptors; this native training resulted in the distinctly American "Sculpture of Empire" style, a period and style that equals, and often surpasses, classical Athens, Renaissance Florence, and French Classical Romanticism.

TOUR VII
DECLINE OF PURPOSE

TOUR SITES

L'ENFANT PLAZA

THE LYNDON B. JOHNSON DEPARTMENT OF EDUCATION BUILDING

THE HUBERT H. HUMPHREY DEPARTMENT OF HEALTH AND HUMAN
SERVICES BUILDING

BRUTAL MISTAKES

In the giddy days of the Progressive era, America's progressive architects and theorists wished to replace the eternal classical with a presumed *zeitgeist*, "spirit of the times." Enthused by an ideology blind to the past, an ideology fashionable in a crumbling Europe, the progressive theorists asserted that classicism had become passé, a dead language incapable of expressing America's progressive destiny. These progressives imagined themselves a vanguard ushering in the inevitable next stage of cultural revolution, the Modern Era.

To theoretic progressives, the United States Capitol was a musty pile of rotting ideals and stinking ideas whose time had long passed. In fact, these architectural iconoclasts opposed the designs for the Lincoln and Jefferson Memorials. Frank Lloyd Wright referred to the Lincoln Memorial as that "most asinine miscarriage of building materials that ever happened." Joseph Hudnut, the prominent dean of the Harvard Graduate School of Design, proclaimed the National Gallery of Art (West Building) to be a "pink marble whorehouse." After World War II, the progressive hegemony had slowly, silently, irreparably wormed its way into the bowels of government, where it would undermine the founding principles with a burrowing, scientific progressivism.

This rejection of our national heritage caused the nation's capital to be vandalized by intrusive Modernistic buildings, including the Hirshhorn Museum, which resembles a World War II gun turret looming over a naïve public; the Brutalist "Ministry of Fear," which is the FBI Headquarters;

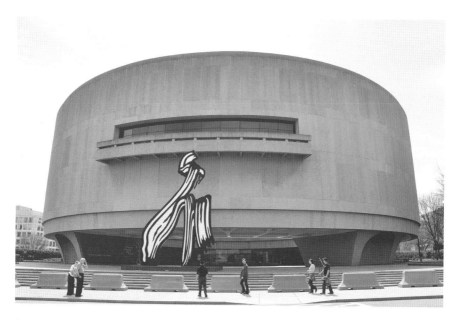

The Hirshhorn Museum and Sculpture Garden; Gordon Bunshaft, architect, 1974. *Lee Snider Photo Images.*

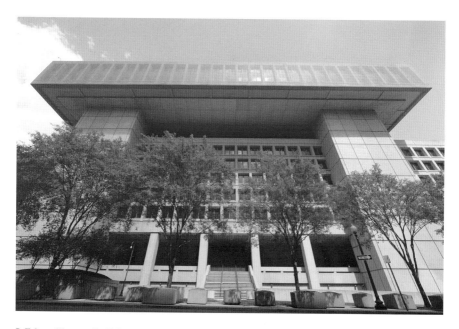

J. Edgar Hoover Building, the Federal Bureau of Investigation (FBI); Carter Manny, Stanislaw Z. Gladyc, architects, 1975. *backpacker79.*

the "black hole" of the Martin Luther King Library; and that most elite of progressive disasters, the "Waste Land" of L'Enfant Plaza, an Urban Planning disaster. I wonder: do government employees in progressivist buildings feel that patriotic pride we citizens feel in "Classical" buildings such as the National Archives, the Lincoln Memorial, the Federal Triangle? Should they?

Each of the Modern, Brutalist buildings that we will visit today was created to quarter enormous departments of bureaucrats in an expanding, progressive state and to gather the ruling-class modernist elites into cliquish clubs: the L'Enfant Plaza Hotel, the Washington Hilton, the Embassy of the People's Republic of China, et alibi. These progressive buildings are intended to bully, to frighten, to impose; they are intended to appear impregnable, alike forts that can be defended from attack—in this the progressive admits his fear, his opposition to a free people. And then, notice that a progressive building's title is a permanent reminder of political patronage, that it proclaims the name of some ambitious, powerful bureaucrat who in large letters stamps his omnipresent name into stone walls and onto each official stationery heading wherefrom come the infinite proclamations, regulations, and stinging fines.

There exist many books on Brutalist architecture whose titles include *Socialist Modernism*, *Soviet Modernism*, *Communist Constructions*, et cetera, yet the definitive book on the progressive's Brutalist American architecture has yet to be written. Various contemporary architectural surveys, including a few in the concluding bibliography, offer apologies for Brutalism in civic settings.

L'ENFANT PLAZA
(UNDER CONSTRUCTION,
RECONSTRUCTION,
DEMOLITION SINCE 1963)

L'Enfant Plaza Masterplan; plaza committed 1968
Planner: I.M. Pei

L'Enfant Plaza Hotel (1971–1973)
Architect: Vlastimil Koubek

Robert C. Weaver Federal Building, Housing and Urban Development
(1965–1968)
Architect: Marcel Breuer

The James V. Forrestal Building, Department of Energy Building
(1965–1969)
Architects: Curtis & Davis; Fordyce and Hamby Associates; Frank Grad
& Sons

L'Enfant Plaza

The plaza's misnaming cannot redeem the failed planning of the famous
I.M. Pei's disastrous L'Enfant Plaza. On any day of the week, at any time
of day, when glancing about us we discover that Pei's plaza is truly a "Valley
of Tombs." Therefore, I suggest that we spare insult to the great civic artist
Pierre Charles L'Enfant by accurately identifying the errors of this place

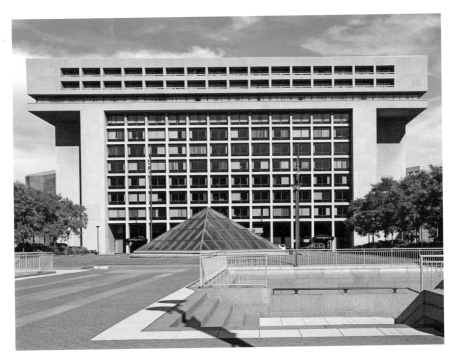

Pei Plaza (L'Enfant Plaza); I.M. Pei, planner, 1968. *Carol M. Highsmith.*

to Pei, the failed urban planner. Pei's plaza was among the progressives' first Urban Renewal projects, and typical of progressive renewal projects, the private homes of families are taken and then demolished to clear land for schemes dear to the ambitions of bureaucrats, politicians and eager architects. In this instance, Pei's Plaza was intended to create the overbearing center of the administrative state, to house government "workers" and to usher in a progressive age. At one time, the *Washington Post* praised L'Enfant Plaza as a "concrete masterpiece"; the *New York Times* hailed it as "progressive, sensitive"; and critic Wolf von Eckardt called this place "a triumph of good architecture," predicting that people would swarm to the plaza, the "city's major urban attraction." Today, progressives are less certain and history looks the other way. In a 2012 session of the progressive American Institute of Architects (AIA), a new scheme was offered to refocus the efforts of progressivism in the conversion of greater L'Enfant Plaza into an all-encompassing Ecodistrict, a model of imposed "Green Planning" consistent with President Barack Obama's 2009 Executive Order #13514, entitled "Federal Leadership in Environmental, Energy, and Economic Performance."

BRUTALIST ARCHITECTURE

Brutalism was a mid-XX-Century expression of progressivism in architecture. It is primarily found in government and institutional state buildings of the Soviet Union, Germany, Britain, France, Japan and the United States, yet Brutalism is occasionally found in comfortable neighborhoods where pretentious modernists intend to discomfort their good neighbors. The style can be recognized by its exposed concrete and rugged brick; its massive, fortress-like appearance; its coldness, its totalitarianism, its sense of urban decay, its aggressive, brutal, criminal appearance; too, you will recognize the style in the rusted, decaying highway overpass.

L'ENFANT PLAZA HOTEL

Vlastimil Koubek imposed over one hundred buildings on Washington, D.C., the majority of which are Brutalist. Others, alike the hollow center of Rosslyn, which blights D.C.'s vista, are merely dull, bland, poor designs that one by one are being removed, alike the National Public Radio building. Yes, it was Koubek who, more than any other architect, created the brutal, ugly, progressive character of mid- to late XX-Century D.C. An academic modernist whose opinions are consistent with progressive attitudes of our nation's founding and traditions, Koubek scornfully commented, "I think that on Georgetown architecture I'd rather not comment at all. You may quote me on that. I wish you would." We have, Mr. Koubek. The L'Enfant Plaza Hotel was by progressives branded a "superb work of urban design" on par with the great plazas built in Paris under Napoleon III. The L'Enfant Plaza Hotel is a listed Mobile 4-Star and AAA 4-Diamond Luxury Hotel, currently closed because its various internal building systems have failed, again.

THE ROBERT C. WEAVER FEDERAL BUILDING

The Weaver Building is named for Dr. Robert C. Weaver, first secretary of Housing and Urban Development and first African American cabinet member. It is the headquarters of the Department of Housing and Urban Development (HUD). It is very much unlike a house: large, cold, confusing; it is very much modern-urban: people have been lost inside the

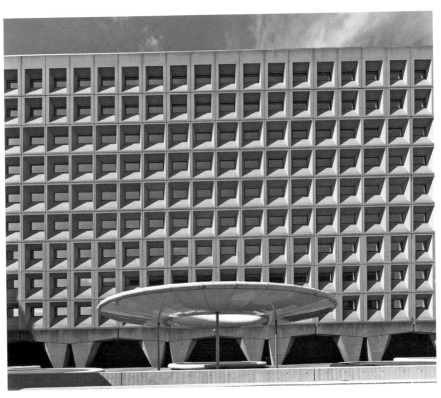

Robert C. Weaver Federal Building, the Department of Housing and Urban Development Headquarters; Marcel Breuer, architect, 1968. *Carol M. Highsmith.*

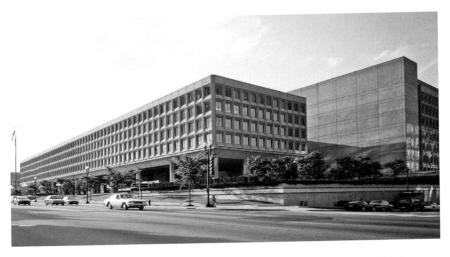

The James V. Forrestal Building, the Department of Energy Building; Curtis & Davis; Fordyce and Hamby Associates, architects, 1969. *Carol M. Highsmith.*

Weaver Federal Building for hours and hours. Why? As the brilliant civic planner Dhiru Thadani has recognized, "The HUD building is ten floors of basement."

THE JAMES V. FORRESTAL BUILDING

Nicknamed the "Little Pentagon," the Forrestal Building was intended to introduce a "new [anti-classical, modernistic] vocabulary" to D.C. architecture, which it did in the inarticulate Babel of those bland office buildings seen everywhere in and around Washington, D.C. Several plans to demolish the Forrestal Building are being considered.

THE LYNDON B. JOHNSON DEPARTMENT OF EDUCATION BUILDING (1959–1961)

Architects: Faulkner, Kinsbury & Stenhouse; Chatelain, Gauger & Nolan

THE LYNDON B. JOHNSON BUILDING

This building has housed many government branches in the merry-go-round of agencies, cabinets, and departments in sundry bureaus, commissions, and offices. The building has quartered the National Aeronautics and Space Administration (NASA), the Department of Health, Education and Welfare (HEW) and, since 1979, the U.S. Department of Education (ED or DoED), also referred to as the ED for the Education Department since it was re-created by the Department of Education Organization Act (Public Law 96-88), signed into law by President Jimmy Carter. The Department of Education is the smallest of cabinet-level departments, with only five thousand employees working through the building. At the L.B.J. DoEd Building's opening in 1961, *Time* magazine praised the building as "ultramodern." Because the building has no character, and because modernist architects do not know how to locate entrances to buildings, curious little-red-schoolhouse façades were later added to lend a kind of interest and to help locate the elusive doors—red is the first color recognized by the eye. Also, you will notice that the L.B.J. DoEd Building, alike most progressive buildings of the mid- to late XX Century, is a simple stack of floors copied from a

The Lyndon Baines Johnson
Department of Education
Building; Faulkner, Kinsbury &
Stenhouse; Chatelain, Gauger
& Nolan, architects, 1961.
Pamela Au.

first-floor row of odd boxed windows; creatively, these boring windows might be of one grid-like proportion or of another grid-like proportion, yet when these window boxes are repeated ad nauseum, architectural awards are distributed for progressively square uniformity.

It seems to me that, by the nature of its purpose, the L.B.J. Department of Education Building needs some reminder of education's high ideals, of civic engagement, of reading, writing, and arithmetic, of those elementary stories that inform and delight the schoolchild and the teacher. But no, not here; government functionaries of this education building are gathered into a mechanized concrete and glass prison from which emanate sterilized, bureaucratic policies and procedures. Would delightful pictures, noble statuary, civic inscriptions and naturalistic architectural details humanize the bureaucrats and improve education? Yes, I think so. Life is not a machine, persons are not cogs to be counted, stamped and sorted, yet a progressive building is seen by its architect as a machine in which to move people, to cause them to flow to the purpose of the building, in Brutalist government buildings to flow as directed by government for government's oppressive function. The idea of a person with a unique purpose and divine spark is anathema to progressive central planning in architecture and in the progressive state.

THE HUBERT H. HUMPHREY DEPARTMENT OF HEALTH AND HUMAN SERVICES BUILDING

(1972–1977)

Architects: Marcel Breuer, Herbert Beckhard and Nolen-Swinburne & Associates

HUBERT H. HUMPHREY

Hubert Horatio Humphrey, Jr. (1911–1978) was a typically liberal-progressive politician who shall serve this examination of our classical heritage. Hubert Humphrey received a master's degree in political science (the notion that politics is a science rather than a civic occupation), served as a bureaucrat during World War II (a supervisor of the Works Progress Administration), became a professor of political science, was elected mayor of Minneapolis and became a United States senator, later becoming Democratic majority whip and then vice president. Humphrey won his party's nomination for president, losing in 1968 to Richard M. Nixon [R], yet so well loved was Humphrey that he was reelected to the Senate, becoming Senate deputy president pro tempore until his death. You will notice that Humphrey was a professional politician, a being rare in pre-progressive America. Humphrey championed human rights, desegregation and peace, causes celebrated by all lovers of liberty; he proposed concentration camps for subversives and felony charges for communists. Legislatively, quixotically, Humphrey promoted full employment through government planning, peace by feeding the world, eradication of disease

and all such conditions harmful or inconvenient to persons; for this consideration he was well loved, for these gifts he was reelected, for this species of spending the national debt increases. Humphrey did not heed Washington's warning that "no pecuniary consideration is more urgent than the regular redemption and discharge of the public debt: on none can delay be more injurious, or an economy of time more valuable."

THE HUBERT H. HUMPHREY BUILDING

This low-rise, Brutalist office building—named for the former vice president—is headquarters of the United States Department of Health, Education and Welfare (HEW; id est, HHH-HEW). The building hovers on a few strategically placed *pilotis* (architecturally inarticulate, stilted table legs) to act alike a raised bridge over the sewer and tunnel below; its large moat of a front "concrete lawn" was created after the building's ugliness demanded distance between itself and the streetscape. It is

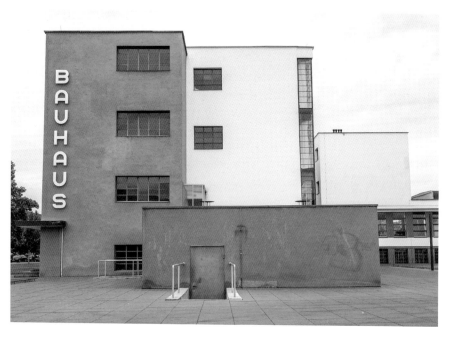

Bauhaus, Dessau, Germany; the Bauhaus art school's iconic building, designed by architect Walter Gropius in 1925, is a listed masterpiece of modern architecture. *Claudio Divizia.*

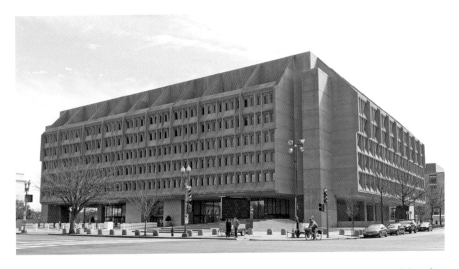

The Hubert H. Humphrey Department of Health and Human Services Building; Marcel Breuer, Herbert Beckhard, Nolen-Swinburne & Associates, architects, 1977. *Carol M. Highsmith.*

among Marcel Breuer's famous buildings. In the last century, the old XX Century, Breuer was among the first students of the first school of Academic Modernism, the Bauhaus, where students were taught to strip away beauty to create easy reproduction on a massive scale, an art of the production line, suitably marketed in public relations campaigns, films, museums, and magazines. You will recognize Breuer's bent-metal and vinyl chairs in Mid-Century museums and rusty secondhand stores; Breuer's buildings were mostly commissioned by industrialists, hipsters, and progressive politicians. The Humphrey Building will serve, in Plutarchian tradition, as comparison.

In general, as far as the subject will allow, you will notice that buildings that are true to the nation's founding principles are beautiful, celebratory or solemn, appropriate to humanity, fitting the vicissitudes requisite of the citizen; then you will notice that buildings true to the tenets of scientific progressivism confront humanity with opposition, that they are scaled to the state, not to the citizen. Choose any building of our classical heritage, hold it in your mind; now, by comparison, oppose that building with the Humphrey Building. You see, yet, I cannot here rest my case; now, by imagination enter each building: Which to you approximates heaven, which hell; which building in form, material, scale and ornament is conducive to human flourishing, which to state functioning? All art is the idea made real;

most all that we see most every day was conceived by the mind and created by the hand of an artist. If I were you, I would with caution choose the artist whose mind I enter. In the vast expanse of the cold, oppressively barren hall of the Humphrey Building, there is one playful little charming "figurative sculpture" of a mother lifting in delight her children (*Happy Mother*, sculptor Chaim Gross). Suspended above is a heavy, ominous, overbearing concrete ceiling. I doubt that the building's architect recognized the poetry; I am certain that the commissioning bureaucrat missed the point.

TOUR VIII
CAPITOL HILL ENVIRONS

TOUR SITES

THE CAPITOL HILL

CAPITOL HILL EAST

CAPITOL HILL WEST

CAPITOL HILL BORDERS

OF THE PEOPLE

THE ANCIENT CITADEL

Experience demonstrates that violence and war are necessary to sentient beings, the more so in human beings, those flesh-eating monkeys who can know Greek and love God; to survive, to mediate the expansive effect of violence and war, wisely we assemble our people upon hilltops that we fortify with materials most convenient, most suitable, usually rock. We find these raised fortifications, citadels, in all landed places of the world: Bratislava, Jerusalem, Thebes, Corinth, Beijing, Aleppo, Bam, Segovia, Edinburgh, Derbent, Yksm (Algiers), Tikal, et alibi, and of course, the Acropolis of Athens, the Palatine Hill of Rome.

As every schoolchild, and some masters of art, know: Rome is surrounded by seven hills, foremost among which is Palatine, where Romulus raised his city's border and where he murdered Remus, his brother, for violating the low border of his city's wall. Here, a diversion, a telling anecdote: in 2007, on the south side of Palatine Hill, beneath the Domus Liva, was found the Lupercal, the cave where Romulus and Remus were suckled. Some scholars, invested in contrary opinion, ridicule the archaeological find and its implication; we remember the ridicule of Schliemann, who discovered Troy and proved a truth of Homer, and Evans, who uncovered the ancestral home of Minos, the palace and its hereditary kings. Of Rome, in brief, in time, some unnamed people were driven off by the Palatines, the Palatines were driven off by the Sabines, the Sabines by Romulus, whose ancestors

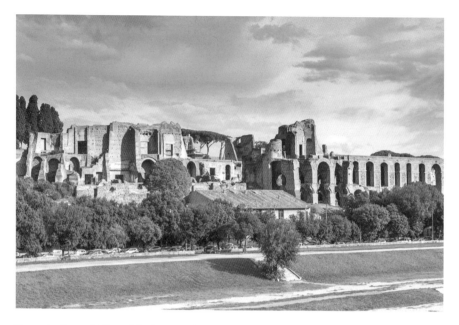

From the floor of Circus Maximus to the Domus Severiana on Palatine Hill. *David Ionut.*

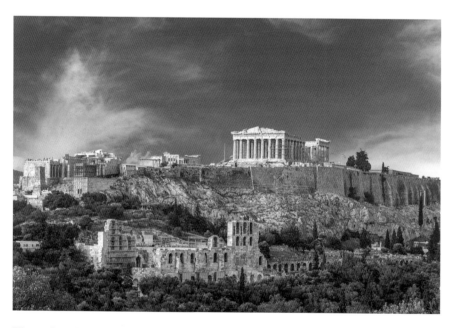

The ancient citadel above the Attic plain, the Athenian Acropolis. *Lambros Kazan.*

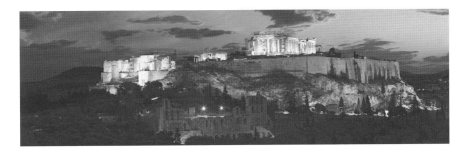

The Athenian Acropolis, Athens, Greece. *Alexey*.

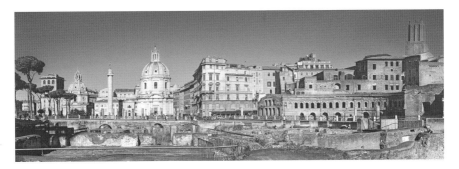

Trajan's Forum, Rome, Italy. *Fabiomax*.

built at the foot of the Palatine the Forum Romanum, Rome's marketplace and government center whose alloyed traditions pass to us through the Vatican into Europe, despite attempts by Vandals, by Ostrogoths, and by Muhammad's progeny to drive off the Romans and eradicate Rome's, well, existence.

Above the Athenian plain rises the fortress of Cecrops, the strong-built House of Erechtheus, the Acropolis, which Theseus and Hippolyta defended from Attica's nobles, which Miltiades defended against the vast army of Darius, later seized and torched by Xerxes, then rebuilt by Pericles to become the capital of an Athenian Empire, at the center of which is the Parthenon, that heart of religion and culture that defines Western Civilization. Before Theseus, before Erechtheus, before Cecrops were those people of the plains and citadel, the Dorians, before them, the Ionians, before them, the Anatolians, and before them, many other peoples from time out of mind. Those of us now breathing are the ascendants of victors, all peoples pass into the shadows of time; let us survive so long as there is in us virtue.

THE WIDOW'S MITE

Local Maryland tradition tells of the Algonquin Indian chief Mannacasset who anchored his wigwam near a mighty oak that stood on a hill along the Potomack. This conquering chief, in hostile war, sized as his prize a comely mother and her daughter, intending to take the mother to wife. The mother refused, and for her refusal, Mannacasset decreed that if she should leave the shade of the great oak, she would be killed. Over the years, this mother took pleasure in raising her daughter, Hope, "Gwawa" in the local tongue. When of age, Gwawa met Tschagarag, a half-European, half-Indian boy with whom she entwined her life. Aged now, the chief Mannacasset died in battle against the European colonials, and beneath the spreading oak was signed the treaty of peace. The old mother was released from her bondage yet chose to stay, the shadow having become her home, so she was granted that land upon which the shadow fell that she might in shade enjoy what was left of life. Around her grew up in stick and stone the village of colonials; the old mother was offered presents and sums of gold for her tree and her shade, yet she refused, bequeathing to her daughter and posterity that home beneath the spreading oak as the cherished relic of homely fortitude. Posterity was blessed with reverence for the tree generation into generation, fulfilling the mother's gratitude, a Widow's Mite to her posterity.

Note: This telling comes to us through diverse sources (including the archives of the Columbia Historical Society), wherefrom property deeds are traced to the 17 percent acre of the Widow's Mite. Records show that the spreading oak grew on the six-hundred-acre settlement of John Langworth (circa 1664); at this time, colonial settlement was opposed by local peoples, and records show that Langworth's children were murdered by the locals. The spreading oak of D.C.'s Washington Heights, sometimes referred to as "Treaty Oak," was estimated to be four hundred to six hundred years old in the 1940s. At this time, architect Frank Lloyd Wright designed a scheme for property development on what had come to be known as Oak Lawn, so great was the progeny of the spreading oak; Wright's scheme was unrealized, yet fire in a neighboring house damaged the tree. An attempt was made in the U.S. Congress to save the spreading oak, the bills failed and in 1948, the old tree was felled. Today, we people who have grown to be natives of the land, we Washingtonians, we Americans, bound together by our Declaration and Constitution, have founded a capital city on a sturdy rock, a rising citadel that will survive, as long as we can keep it.

THE CAPITOL HILL

New Troy, Jenkin's Hill

In 1663, Second Lord Baltimore granted to George Thompson 1,800 acres inclusive of the property entitled "New Troy"; six times the property changed hands before engrantment to the Federal District, and never once did the name "Jenkin" occur. The first we learn of the erstwhile Mr. Jenkin is in letters from L'Enfant to Washington, one such letter reading, "For other eligible situations…I could not discover one in all respects so advantageous… for erecting the Federal Hse. [as] the western end of Jenkin's Heights [which] stands really as a pedestal waiting for a superstructure." We surmise that L'Enfant, when exploring, met the enterprising, mythological Mr. Jenkin (reputedly, owner of an apple orchard quite distant from New Troy) on or somewhere about the hill. L'Enfant, in identifying the place to Jenkin, lent to Washington and Jefferson a name for the spot, neither patriot knowing that the United States Capitol would be constructed on that land named for those Trojans driven from Troy by Achilles to found, first, the New Troy of Rome and then, in precedent, the New Troy of Washington, D.C. This hill would, in truth, become the pedestal for L'Enfant's "superstructure," a monument, in fact, many monuments: the United States Capitol Building; the Library of Congress Jefferson, Adams, and Madison Buildings; the United States Supreme Court Building; the Folger Shakespeare Library Building, et cetera.

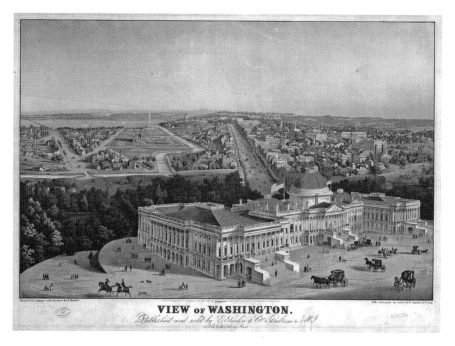

VIEW OF WASHINGTON.

Bird's-eye view of Capitol Hill. *Architect of the Capitol.*

CAPITOL HILL

In 1827, within the crypt of the Capitol Building, encircled by stout, Greek Doric columns, under the active eyes of statues representing persons of the thirteen original British colonies, Charles Bulfinch caused to be placed within the stone floor a star marking the center point of the District's four quadrants, the point from which all streets would be arranged and numbered. From this star, alike a Northern Star fixed of motion, one mile due east, toward the rising sun, was to be a public square at whose center was intended a column "from whose station, all distances of places through the continent, are to be calculated." As chance, or ineffable design, causes consequences, upon this spot within Lincoln Park is the Emancipation Memorial, which depicts President Lincoln freeing from bondage an American slave and which, in its entirety, was funded from the dollars and the pennies of emancipated slaves. Another curious, geographical accident just worthy of mention: Behind Paul Cret's Organization of American States Building is the geographical center of the Federal District, as originally constituted, and at this center is the rather poorly made statue of Xochipilli, Aztec god, child-prince of

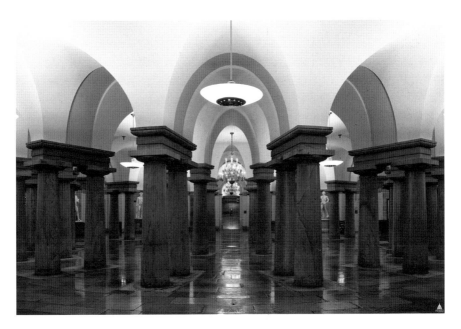

The Crypt: forty Doric columns uphold groined arches; on the floor a stone star denotes the point from which all streets are measured. *Architect of the Capitol.*

flowers. If a geometer, I might discover for you the center of the ten- by ten-mile-square city that once contained one hundred square miles, now by circumstance reduced to sixty-eight, and in discovery draw some allusion, yet as we draw away from the purpose we draw toward illusion, so we are probably wise to, at this point, let it go.

THE GOLDEN MILESTONE

The Milliarium Aureum, the "Golden Milestone," was erected by Emperor Caesar Augustus near the Temple of Saturn at the center of the Forum Romanum, the Roman Forum, the monument from which all roads are measured, the point to which all roads lead. In this milestone, L'Enfant was no less ambitious than was Caesar Augustus, yet L'Enfant was not emperor, and neither were Washington and Jefferson, who, on the whole, supported L'Enfant's ambition but who, although officers of state, were not dictators. L'Enfant's vision in this, and in many another particular, was not realized. We have seen that the actual, eventual little milestone, the Jefferson Pier, was

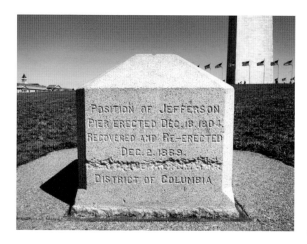

The Jefferson Pier, which chiseled-away line would read, "being the center point of the"; 1804. *Something Original at English Wikipedia, CC BY-SA 3.0, commons. wikimedia.org/w/index. php?curid=35811644.*

placed among the nation's memorials on the great national lawn, below the towering obelisk and the row on row of quiet columns and modern marble walls. If L'Enfant's vision had been realized, you would have seen east of the Capitol Building a public square alike Athens' agora, alike all great squares of activity in commerce; in fact, L'Enfant intended this square to be no less magnificent than was Rome's Forum, an economic capital, the economic capital of these United States, and if it had been, New York, as it is, would not be. What exactly did L'Enfant envision: "around the Square of the Capitol along the Avenue from the two bridges of the Federal house, the pavement on each side will pass under an arched way, under whose cover Shops will be most conveniently and agreeably situated. This street is to be 160 feet in breadth, and a mile long."

What exactly did L'Enfant create: Alike any artist, L'Enfant worked to realize his plan in whole, instructing his workmen to construct the commercial streets east of the Capitol, while the District commissioners directed funds toward the public buildings west of the Capitol; the streets, sans buildings and people, were constructed; L'Enfant was fired; and the empty streets were left to become what they would. And here grew up the quiet, residential neighborhood of Capitol Hill.

CAPITOL HILL EAST

FOLGER SHAKESPEARE LIBRARY (1930–1932)
Architect: Paul Phillipe Cret
Sculptor: John Gregory

RESIDENTIAL TOWNHOMES (MOSTLY XIX CENTURY)
Architects: Numerous and various

WILLIAM SHAKESPEARE

It is curious that the ancients seldom mention the "I" of the inner man, that being, other than the immortal soul, whom the Greeks regarded as fixed, unchanging, susceptible, defenseless against fate. St. Augustine, bishop of Hippo, recognized the malleable character of the inner man, affected, as it is, by circumstance, by will and occasionally by epiphany, that condition by which we approach God. Elizabeth I and her intellectual fellows assumed, much as did the Bishop of Hippo, an inner personality lineally dimensional, yet Shakespeare self-conceived, Shakespeare invented the man who in shaping himself shapes his fate and shapes the larger world, multi-dimensionally. In this, it is most appropriate that the library of the self-shaping man should be located in the self-shaping country.

FOLGER SHAKESPEARE LIBRARY

This library holds the world's largest collection of William Shakespeare's printed works and is a major repository for rare materials in the age of Shakespeare, an age in which we continue to participate. The library was established by Henry Clay Folger and his wife, Emily Jordan Folger; the library's first director was Joseph Quincy Adams Jr., scion of America's Adams family.

PAUL PHILLIPE CRET

Cret was a Beaux Arts architect, a leader in the development of American Art Deco and Stripped Classicism, of which this library is a prime example. Always the appropriate innovator, Cret relocated the oversized metopes to ground level, where we may closely appreciate the narrative statuary. The library's interior is among Washington, D.C.'s most beautiful spaces, and the

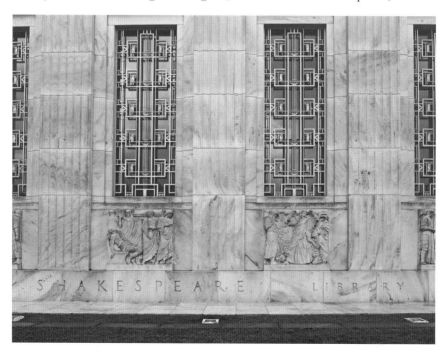

Folger Shakespeare Library, detail; Paul Phillipe Cret, architect; John Gregory, sculptor, 1932. *Pete Spiro.*

theater remembers the character of London's Shakespearean-Elizabethan theaters. For your pleasure and elocution, I urge you to read the building and take in a performance.

JOHN GREGORY

This sculptor of America's great age outlived his epoch. His nine narrative reliefs carved into the library derive from various Shakespeare plays. Test yourself; guess at the subject before reading the title. The open structure of the statuary's marble is not suitable to its present location; the statuary should be moved indoors and replaced with a facsimile in a durable material, as is found in the important works of Florence, et alibi.

CONTRACTOR BUILT

Imagine, if you will, the opportunity of the neighborhood surrounding the nation's Capitol, the men free to exercise their liberties to create advantage for themselves and their families, how with strong backs, and stronger minds, they formed inchoate earth into a place of comfort and security for their wives, children, and fellows. Picture the shovels, the muscular backs glistening in moisture, the hot kilns, the bricks stacked row on row on row by chapped hands with rough trowel and gritty mortar, the trees with sharp axes by knotty arms felled, planked, stacked, carried, nailed with iron hammers, and all of this in style, in tradition beautifully expressing our rise through three thousand years, the Federal, the Greek Revival, the Italianate built for the profit that would feed and shelter their families, and picture these families in tradition, in manner, in style made secure to pursue those enterprises of improvement and fulfillment that are the purpose of civilized society and you might better appreciate free enterprise, the masculine arts, and your comfort.

Capitol Hill offers a library of American building styles; here you will find many fine townhouses, row houses and apartment houses rich in variety: Federal, Greek Revival, Italianate, Queen Anne, Richardson Romanesque, Classical Revival. I recommend a guide book of styles that you might learn our country's architectural heritage; if not, you might stroll from the Capitol steps along East Capitol Street to Lincoln Park and there allow this book to serve as introduction:

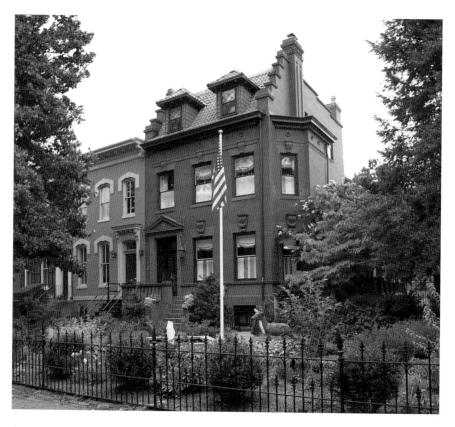

Antonio Malmati House, East Capitol Street; George S. Cooper, architect, 1902. *Carol M. Highsmith.*

Late Greek Revival: 321 and 322 East Capitol Street; Emil S. Frederick, draftsman to Robert Mills.

Italianate: 325 and 327 East Capitol Street; Augustus G. Schoenborn, draftsman under Thomas U. Walter (Schoenborn claims credit for U.S. Capitol dome's structural system); circa 1880.

Richardsonian–Queen Anne hybrid: 506 East Capitol Street; att. William Sheets, architect; 1887.

Excellent Queen Anne style: 616 East Capitol Street; Appelton P. Clarke Jr., architect-builder; circa 1885.

Folksy, Italian Renaissance: 712 East Capitol Street; Antonio Malnati, stonemason, owner-builder; 1902.

Beaux Arts: 822 East Capitol Street…the list goes on…

Best to acquire a stylebook and get to learning.

CAPITOL HILL WEST

UNION STATION (1903–1908)
Architect: Daniel Burnham
Sculptors: Louis Saint Gaudens and Lorado Taft

ULYSSES S. GRANT MEMORIAL (1902–1924)
Sculptor-Architect: Henry Merwin Shrady

BIG PLANS, BIG ACCOMPLISHMENTS

Make no little plans; they have no magic to stir men's blood....Make big plans; aim high in hope and work, remembering that a noble, logical diagram once recorded will never die, but long after we are gone be a living thing, asserting itself with ever-growing insistency. Remember that our sons and our grandsons are going to do things that would stagger us. Let your watchword be order and your beacon beauty.

As it happened, the aesthetic sons and daughters of Daniel Burnham did not in aesthetics do things that would have staggered him, except perhaps in war, the accomplishment of victory in World War I and World War II where those architects and artists bled out their lives in the titanic battle for freedom. What came after was the modern, progressive aesthetic brought to these shores, our America, by Europe's aesthetic revolutionaries. You

will find that Europe's artists and architects from World War I through World War II, and after, insinuated themselves into our art schools, art museums and institutions, the vanguard of progressivism, aesthetically reckless, martially submissive. Bold and expansive, with energy and confidence, Union Station and the U.S. Grant Memorial are evidence of where aesthetic America was leading until the wars, the death of our heroes and the usurpation of America's generative aesthetic by the extremes of Europe's revolutionary vanguard.

UNION STATION

Named for the Union that preserved continental American liberty, Union Station welcomes through its Constantine arches and into its Diocletian interior thirty-two million travelers a year. Upon the columns are eighteen-foot-high heroic sentinels by Louis Saint-Gaudens; upon the frieze, paired to the sentinels are beckoning quotes: MANS IMAGINATION HAS CONCEVIED ALL NUMBERS AND LETTERS—ALL TOOLS AND VESSELS AND SHELTERS—EVERY ART AND TRADE—ALL PHILOSOPHY AND POETRY—AND ALL POLITIES, et cetera.

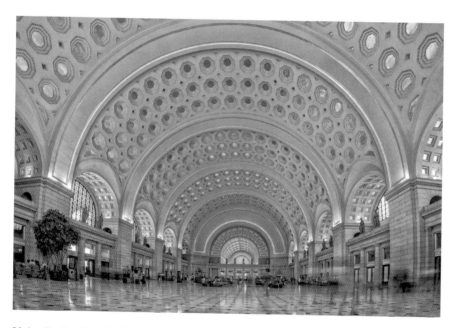

Union Station, interior; Daniel Burnham, architect, 1908. *Andrea Izzotti.*

THE COLUMBUS FOUNTAIN

This fountain is cause for celebration; each person reading these words ascends from Christopher Columbus' Renaissance daring and Christian virtue, and we each would not be as we are if not for the explorer. As you might imagine, the Catholic service organization the Knights of Columbus aroused in Congress an enthusiasm for the fountain and commissioned the great Lorado Taft (sculptor of *The Fountain of Time*, author of the *History of American Sculpture*), who brought a historian's understanding to the fountain's concept and design—you will recognize the allusions. His shaft reads: TO THE MEMORY OF CHRISTOPHER COLUMBUS WHOSE HIGH FAITH AND INDOMITABLE COURAGE GAVE TO MANKIND A NEW WORLD—BORN MCDXXXVI–DIED MDIV.

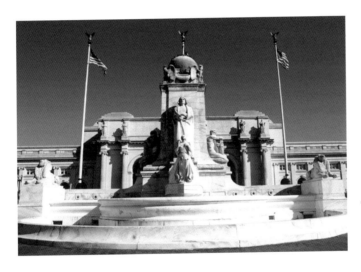

Columbus Fountain; Daniel Burnham, architect; Lorado Taft, sculptor, 1912. *MS Dogan.*

HIRAM ULYSSES GRANT

Republican U.S. Grant was the eighteenth president of the United States and the commanding general who led the Union armies to victory over the Confederacy in the War to End Slavery and who in person received at Appomattox the surrender of Robert E. Lee. (Of the name: "Ulysses" is the Latinized name of the Greek "Odysseus," Homeric hero, et cetera; the initial "S" has no meaning, except as abbreviation of "useless" given him by his West Point fellows—I prefer "U.S." for "United States" Grant.)

THE GRANT MEMORIAL

Upon Union Square, at the summit of the Capitol Reflecting Pool, is located the Ulysses S. Grant Memorial. On horseback, a composed U.S. Grant stands above and apart from the chaos of war, the madly careening caisson of artillerymen and terrified horses, the racing flag-carrier, the cavalry charge, the fallen, trampled soldier. At Grant's base are four powerful lions in various states of repose, each guarding the numerous flags. When created, the memorial was the largest bronze sculpture cast in the United States.

HENRY MERWIN SHRADY

H.M. Shrady was that sculptor of America's great age who created many exemplary statues, including *George Washington at Valley Forge*, *Robert E. Lee*, et cetera. Shrady was hospitalized when designing the statues, ill during their creation and died two weeks before the U.S. Grant Memorial's unveiling. The fallen, trampled soldier is a self-portrait of the artist, a portrait that, to my mind, stands in for the robust, lost potential of those American artists fallen in the great wars.

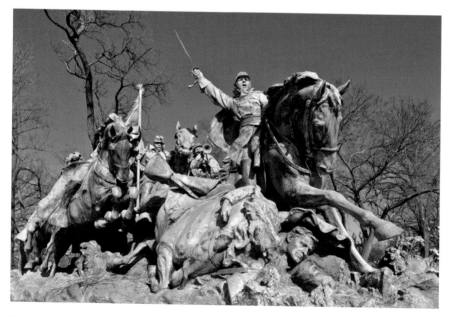

The *Cavalry Group*, Ulysses S. Grant Memorial; Henry Merwin Schrady, sculptor and architect, 1924. *Brandon Bourdages.*

Congressional Cemetery (1807–present)
Arlington National Cemetery (1864–present)

Cemetery

The need, the habit, the tradition of burial is universal among the peoples of earth. Each culture has burial traditions unique to itself; in Western Civilization, we lay our dead within the lap of earth, the "cemetery," a Greek word meaning "resting-place," and Greek cemeteries, alike ours, featured headstones, which in Greek are known as *stele*, stone markers into which are carved inscriptions, symbols, dates and portraits. In Greek and in English, aboveground graves are known as "tombs," from the Greek *tymbos*, a "burial mound," which might be a sarcophagus, mausoleum or columbarium. Sarcophagi (from the Greek, meaning "flesh-eating," for the limestone that decomposed flesh) are found the world over. A remarkable early example is the Cretan, pre-Homeric Hagia Triada. The word "mausoleum" derives from the tomb of the Hellenistic king Mausolus. His tomb building, the Mausoleum of Halicarnassus, is among the Seven Wonders of the World. "Columbarium" is from the Latin for "dove," referring to the dovecote, the home for doves, so much do the urn cells of the columbarium resemble banks of birdcages. Here we remember Sophocles, Antigone and the law of nature, God's law that demands the ceremony and burial of the dead, a law predating kings.

American, mid-XX-Century cemeteries were pleasure parks where we might spend the afternoon in stroll or picnic, sharing time and memory with departed family, lovers and friends. Washington is especially fortunate in its beautiful, meaningful, pleasurable cemeteries, a few of which are Rock Creek Cemetery, Oak Hill Cemetery and those cemeteries of service and sacrifice, Congressional Cemetery and Arlington National Cemetery, cemeteries that flank Capitol Hill in meaning, location, and purpose.

CONGRESSIONAL CEMETERY

East of the Capitol, bordered by the Anacostia, on the L'Enfant grid is the cemetery of our national memory where are found the tombs of congressmen and natives of the District of Columbia, Americans all, each tomb revealing who we were, who we are, and what we might become. Here: Elbridge Gerry, signatory of the Declaration of Independence, vice president of the United States; Dr. William Thornton, physician, inventor, painter, architect, designer of the U.S. Capitol Building; George Hadfield, architect, D.C. City Hall, Arlington House (the home of Robert E. Lee); Robert Mills, freemason,

Congressional Cemetery cenotaphs; Benjamin Henry Latrobe, architect, 1833–76. *Carol M. Highsmith.*

architect of the Washington Monument and the U.S. Treasury Building, et cetera; General Alexander McComb, commander of the U.S. Army, hero of the Napoleonic Anglo-American War (1812); Mathew Brady, photographer, chronicler of the War to End Slavery; Taza, Apache chief, diplomat; John Philip Sousa, composer of operas and marches, "Stars and Stripes Forever," et cetera; Belva Ann Bennett Lockwood, suffragist, attorney who argued before the U.S. Supreme Court, candidate for president; Adelaide Johnson, sculptor, feminist whose husband accepted her name, egoist who claimed to be one hundred when eighty-eight; Mary Fuller, desperately famous, insane screen actor; J. Edgar Hoover, blackmailer, director of the FBI; Warren N. Robbins, Jewish émigré, owner of a Frederick Douglass home, founder of D.C.'s African American Museum; Marion Barry, drug addict, sex addict, felon, leader of the civil rights movement, mayor of Washington, D.C.; Leonard P. Matlovich, veteran, politically and socially active homosexual who died of AIDS. Here, too, you will find the cenotaphs designed by Benjamin Latrobe, "cenotaph" from the Greek, meaning "empty tomb," often memorializing persons buried in some other place. Latrobe's cenotaphs partake of reason, French utopianism, the Enlightenment; and then, the yawner of some contemporary artist-arts-administrator who pretentiously, sideways tipsied his black cube gravestone.

ARLINGTON HOUSE

Mostly I have spared you the anecdotes of personal reference, my participation in public projects with public persons, the statues I have made, the Byzantine machinations of this District, friendships, colleagues, competitions, aesthetic enemies, yet I would like to share a personal pleasure: Reclining at night beneath star, moon or cloud, against Bacon's Doric columns of the Lincoln Memorial, past Friedlander's golden equestrian statues, over Kendall's elegantly swelling Memorial Bridge, up the high hill to Arlington House, and here a poetry unmatched in the history of political coincidence, if any such thing is coincidence; for Lincoln's part, well, he assumed all things the working of, how might I say…to the story, to make of it what you will.

George Washington Parke Custis, grandson of Martha Washington, upon Mount Washington had constructed a home informed by the Temple of Hephaestus in Athens, Arlington House. This impressive house passed to Custis' lovely daughter, Mary Ann, who soon would wed the dashing officer

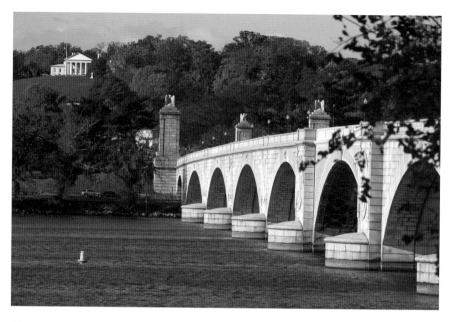

Memorial Bridge to Arlington House and National Cemetery; McKim, Mead, and White, architects of the bridge (William Mitchell Kendall, designer), 1932. *Mdgn.*

Robert E. Lee—R.E. Lee, the son of Henry "Light-Horse Harry" Lee, hero of our War for Independence, friend to General Washington, father of our country. On the eve of the War to End Slavery, President Lincoln offered to Lee command of the U.S. Army. Lee declined, abandoning Arlington House to assume command of the Confederate forces and to defend his country, Virginia, from invading Federals. Arlington was soon occupied by the U.S. Army. Montgomery Meigs, quartermaster general of the U.S. Army, was a colleague and friend to Robert and Mary Lee, familiar with Mary's rose gardens that flanked the house, and it was here that General Meigs interred his son, Lieutenant John Rodgers Meigs, in a fashion of horizontal stele, and here other officers, and other soldiers almost beyond number, and here—so that Mrs. Lee and her traitorous husband might never return—beside her grove, beneath a martial sarcophagus, within a tumulus, a "common mound," the unidentified, intermixed bodies of 2,111 Union and Confederate soldiers. Robert E. Lee was never to return to Arlington House, his Olympian perch overlooking Washington, becoming instead president of Washington University (later Washington and Lee University), where ever after the old, defeated general would knowingly march in parade, out of step. I, of course, recall those other battles most

decisive in the direction, in the survival of Western Civilization, in the tumulus of Chaeronea, in the tumulus of Marathon, in the tumulus of Thermopylae for which Simonidies composed the epitaph "Go tell the Spartans passerby, that here obedient to their laws we lie." The Arlington Tumulus reads, "Beneath this stone repose the bones of two thousand one hundred and eleven unknown soldiers gathered after the war from the fields of Bull Run and the route to the Rappahannock; their remains could not be identified, but their names and deaths are recorded in the archives of their country, and its grateful citizens. Honor them as of their noble army of martyrs. May they rest in peace."

Wars are decisive. Some cry, "Peace, peace." and peace is received, in defeat; in victory, a nativity, a struggle in that awkward time between birth and death where we become one thing or the other thing, here, for a brief time, in liberty, citizens of a peaceful republic encompassed by hungry and envious persons, ambitious military genius, ruthless, expansive nations and the progress of time that devours all things.

ARLINGTON NATIONAL CEMETERY

Within the practical square mile of Arlington National Cemetery are buried 400,000 patriot warriors who have served military necessity in our one hundred or so wars and conflicts since, and including, the War to End Slavery; we witness some 7,000 more ceremonious interments each year. There are more persons, events, and distinguished monuments here

Heroes' graves, Arlington National Cemetery. *Orhan Cam.*

than can in practical reason be mentioned; it is enough to say that each American owes to our honor, pilgrimage. The war for Western Civilization continues within and without our national borders; recently, progressives won the battle to force the pentacle (symbol of Lucifer and witchcraft) into this resting place of our heroes, national family and friends.

TOUR IX
COLONIAL ALEXANDRIA

Tour Sites

Carlyle House and Lower King Street Warehouses

Lower Prince Street and Local Alexandria

The Lyceum and the Appomattox Statue

George Washington Masonic National Memorial

BRITISH AMERICA

Preface

Where Great Hunting Creek opens to the Potomack River there grew up the little village of Belhaven, where George and Lawrence would trade tobacco grown on Augustine Washington's plantation, later named by Lawrence, Mount Vernon. Around this time, in the twenty-second year of the reign of George Augustus, King of Ireland and of Britain, Prince Elector of the Holy Roman Empire, was presented a petition from "the inhabitants of Fairfax in Behalf of Themselves and others praying that a Town may be established at Hunting Creek Warehouse on Potomack River." Accordingly, it was "resolved that the Bill do pass. Ordered, that Mr. [Lawrence] Washington do carry the Bill to the Council for their concurrence." The bill was carried, with amendments, and soon George Washington would survey the area, recording on his map "the plat of land whereon now stands the town of Alexandria"; id est, the property of Captain John and Captain Phillip Alexander, eponymous founders of Alexandria. Here, in this spot, named by Sir Walter Raleigh the colony of "Virginia" in honor of the Virgin Queen, Elizabeth I, and here along the coast explored by Captain John Smith, friend to the Powhatan princess Pocahontas, was established in 1749 the town of Alexandria, Virginia, where we find picturesque streets named King, Queen, Prince, Princess, Duke, Fairfax (for Lord Fairfax), Royal, Pitt (for William Pitt, First Earl of Chatham), Saint Asaph (later named for the bishop of Saint Asaph) and Cameron (for Thomas, sixth Lord Fairfax,

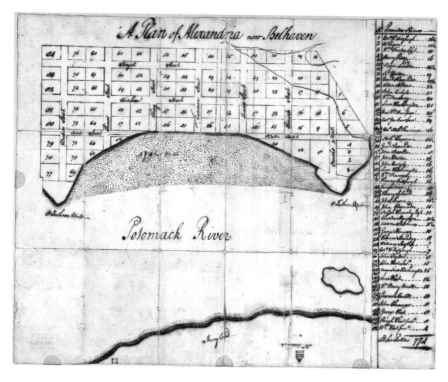

Map of Alexandria, Virginia ("A Plan of Alexandria now Belhaven"); George Washington, draughtsman, 1749. *Library of Congress.*

Baron Cameron, richest man of Potomack's Northern Neck). It is along these streets that we shall trace our growth from quaint colonial villagers to benevolent masters of the world.

THE BRITISH EMPIRE

We English-speaking people find our genesis in the Gallic Wars with Julius Caesar's invasion of Britain (years 55 and 54 BC) at Kent, the River Thames, Essex and Hertfordshire, whereupon we began our long assimilation into free Roman citizenship in the edict of Caracalla (AD 212), the incorporation into the *ius gentieum* (the natural, common law of nations) and the sometimes employment of the *ius civile* (codified body of Roman law, the form typical of continentals and of some formerly continental American colonies, Louisiana, et alibi). This flexible, adaptive,

political, legal, linguistic, and cultural inheritance of an *imperium Romanum* prefigured the formation of a British Empire, an empire in 1749 inclusive of farmers, merchants, and tradesmen who carved from spacious woods a little village along Potomack's shores.

BRITISH COLONIALS

British colonials were remarkable people, communitarian rather than ruggedly individual, and yet self-reliant, people of common sense, still, as London booksellers testified, better read than Londoners, especially in law. They were a people of restraint in matters of taste, moderated by necessity, conscious of subordination, because subordinate, ambitious of improvement. American British colonials were particular in morals, those habits by which character is formed; they were assiduous in ethics, that practice of virtue most "likely to make a man's fortune" (see, Benjamin Franklin). We have noticed that our homes are a form of self-portrait; in Alexandria, we will recognize in warehouses, townhouses, villas, and a transcendent monument, architectural portraits of ourselves in national infancy, that moment contiguous with the War of Independence from Britain and the formation of these United States.

CARLYLE HOUSE AND LOWER KING STREET WAREHOUSES

Carlyle House (1752), 121 North Fairfax Street
Architect: John Carlyle

Peterson-Fitzgerald Warehouse (1795–1797), 101–105 South Union Street

Sugar, Slavery, Tobacco

Transatlantic slavery began with the European appetite for sugar, an appetite stimulated by pleasure to habit. In 1493, Christopher Columbus on his second transatlantic voyage carried to Hispaniola (Haiti, the Dominican Republic) Mediterranean sugar cane and the plantation system. Within decades, Brazil would export sugar to Europe in thousands of tons; by 1650, some 800,000 Africans would slave in South America's production of sugar. North America is mostly ill suited to alien sugar cane yet well suited to its native tobacco; soon, alike sugar, the European pleasure in tobacco grew habitual, indentured European servants proved insufficient in production, and African slaves became necessary to feed the tobacco habit, a habit that enslaved in Virginia some 250,000 Negroes during the final period of British colonial control, a control that ceased in 1774 when America's Continental Congress banned trade with Britain and vowed to abolish the importation of slaves.

GEORGIAN ARCHITECTURE

"Georgian" is that uniquely British interpretation of Palladio's researched experiments in classical building type, plan, and detail; it is a style pleasingly symmetrical, agreeably proportioned, and neatly adorned with boldly restrained ornament. The Georgian is in architectural character what the Hanoverian Kings (George I through George IV, circa 1714–1837) aspired to in life, a grand yet studied gentility that would influence all subjects the Crown might touch. This style, alike the kings, would be variable through time, place and purpose; it would find fullest expression in the villa, the English country house, where every man might be a king.

CARLYLE HOUSE

John Carlyle was the typical British subject of fortunate birth; scion of landed Scottish gentry; émigré to Virginia; a successful merchant who married into the family of Lord Fairfax; who developed a foundry, a forge, a mill; who traded wholesale with England, retail in Alexandria; who acquired three plantations; a goodly man who, with a father's care, considered his

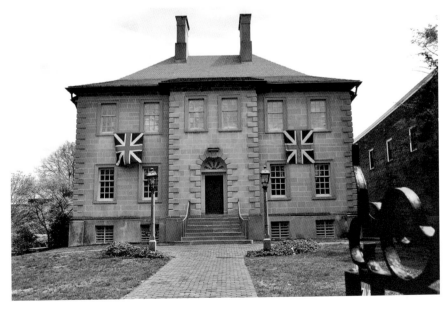

Carlyle House, Alexandria, Virginia; John Carlyle, architect, 1752. *Lee Snider Photo Images.*

dear slaves "famely," a family enslaved rather than adopted. Carlyle's house, too, is typically British, Georgian by experience, likely designed by Carlyle himself from memories of those English country houses he visited when trading in England. It is less builder's pattern-book than is Mount Vernon, less studied than is Jefferson's brilliant Monticello, yet Carlyle House is sincere in aspiration, perfectly demonstrating the imperfect colonial understanding of correct manner in design; id est, a rigidity in symmetry, an awkwardness in window bays and in other details, charming, if not quite right. We should not leave Carlyle House without the mention that here General Braddock with Major Carlyle planned British action in the French-Indian War and that here, in pleasure and in business, were found George Washington, Aaron Burr, John Paul Jones, John Marshall, George Mason, Thomas Jefferson, and other British subjects who would in the course of events become American Patriots.

WAREHOUSES

Where King Street is generated at the Potomac River there are found numerous warehouses shouldered together alike comfortable neighbors. You will find them to be suitably plain, presenting to the world a fabric cut close to the chest, bilaterally symmetrical in face, demonstrating some minor distinguishing personality in choice of decorative cornice. The warehouses, alike their owners, were friends, neighbors, business associates, each engaged in trade or commerce in grains, hay, seed, salt, flour, tobacco;

King Street Warehouses, Alexandria, Virginia. *Office of Historic Alexandria, R. Kennedy.*

and the warehouses adapted, as did the owners, from British colonials into Americans, flexible in use, modified to purposes various these two hundred years. In context, the Peterson-Fitzgerald Warehouse attracts our notice, as much for its builder, Colonel John Fitzgerald, aide-de-camp to the general at Valley Forge, as for its purpose; then, all manner of goods in storage and trade necessary to the production of civic life, now, serving the amusement of a settled population as restaurant and coffee house. In passing, we note that Colonel Fitzgerald was mayor of Alexandria in 1787, the year of the United States Constitution.

LOWER PRINCE STREET AND LOCAL ALEXANDRIA (CIRCA 1750)

COLONIAL TOWN PLANNING

With a bronze blade drawn by a white steer and a white cow, Romulus plowed a furrow marking the defensive borders of Rome, a plowing repeated in sacred ritual at the founding of each colonial Roman city, a plowing annually observed to secure the gods' continuing favor. Londinium (London), Camulodunum (Colchester), Isca (Exeter), et alibi are among the seventy-three colonies of Roman Britannia, each developed upon that form most suited to military and to commercial application, the grid. Both the continental and the British favored gridiron plans in colonial cities, cities inspired by Vitruvius, the ideal city, the City of God, and conceived in science, humanism, and secular government, the Enlightenment.

ALEXANDRIA TOWN PLAN

Traditionally, we picture the seventeen-year-old colonial George Washington holding at the river's shore a chain's end, at the other ending, John West, Fairfax County surveyor, with tripod, plumb, compass, paper and pen nearby, drawing and marking the streets of Alexandria in craftsmanship alike Pharaoh's Egyptian surveyors, alike Alexander's survey of Alexandria, alike Sulla's survey of Florence, alike all such surveys then and now. Technologies develop; essential practice, not so much. Alexandria, Virginia's original sixty-acre town plan might have been Alexander's or

Cleopatra's Alexandria, so much do the Egyptian and American plans mirror one another in grid, in maritime and military purpose, at shore's edge, in commercial, civic and domestic proportion along commodious streets organized block by block, by block.

THE FEDERAL DISTRICT

We believe that the worship of Jupiter Terminalis was by Romulus initiated in the Terminus, a spirited stone marking Rome's boundaries. Alexandria, too, has boundary stones, stones which were set to mark the limits of the ten-mile-square Federal District, stones whose position was determined by Benjamin Banneker at Jones Point on a deep night when six stars pointed the southernmost corner of the District, the spot upon which luminaries of Alexandria's Masonic Lodge ceremoniously placed the Federal District's terminal stone.

FEDERAL STYLE

"Federal" designates that style of American architecture distinguished from the Georgian, a style Republican rather than Imperial Roman, a style restrained, upright, alike a gentleman with whom you might shake hands, rather than a Georgian royal toward whom you might be compelled to bow. It is a style in precision tutored by contemporary excavations at Pompeii and Herculaneum. Specifically, it is that style consciously chosen by Thomas Jefferson to reference Republican values, that style through Jeffersonian reason and invention that most fully describes the essence of we Americans.

THE FEDERALIST STREET

Remarkable among all surviving Federal examples, for beauty, variety, and excellence, are the several blocks of Prince Street. For beauty, we notice correct proportion of architectural parts and fitting decorative detail; for variety, the very many interpretations of domestic theme; for excellence, we might single out the ensemble, the polite consideration each façade pays to the other, a genteel, Republican consideration foreign to contemporary, willful, conceited modernism.

Lower Prince Street (early XX-Century photograph), Alexandria, Virginia. *Historic American Buildings Survey (Library of Congress).*

NEW URBANISM

Others have noticed the healthful qualities of well-designed, fittingly apportioned cities, as in Old Town Alexandria. The first Congress of the New Urbanism was held here on Prince Street at the Athenaeum in 1993. Peter Katz, Andres Duany, Dhiru Thadani and others have appreciated the relationship of Alexandria's street width to building height; the urbane distribution of domestic, civic, commercial and public spaces; the integration of living and working space, which allows for happy and prosperous lives; the sense of communitarian prosperity, neighborhood and friendship. Some, alike Greenberg, McCrery and Alexandria's own Robert Bently Adams and Al Cox, have extended to the present the architectural tradition of Carlyle, Washington and Jefferson.

SITE 3

THE LYCEUM AND THE
APPOMATTOX STATUE

THE LYCEUM (1839)
Architect: Benjamin Hallowell

APPOMATTOX STATUE (1889)
Sculptor: Caspar Buberl

COLONIAL, FEDERAL, UNION

Dates remarkable in Alexandria's history include the permission of King George II to allow the founding, 1749; ceding of Alexandria from the State of Virginia to the United States to form the Federal District (later, Washington, the District of Columbia), 1789; retrocession of Alexandria from the United States to Virginia, in part economic, in part opposition to planned District-wide abolition of slavery, 1847; Federal occupation, Union troops land on the Potomac River at King Street, 1861; Union army departure, leaving the city destitute, overflowing with sick, ill-used and dying contraband (escaped slaves), 1865; rescindance of military rule, 1869; readmittance to Union, 1870.

THE LYCEUM

Aristotle, who has enriched our intellectual world more than any other, founded his first school in the wooded hills of Mieza, where he tutored Alexander II (the Great), Ptolemy I, Cassander, Hephaestion, et alia (those kings, those generals, those men of active genius who more than any other affected the course of civilization). At his second school, the Lyceum at Athens, Aristotle developed a curriculum of subjects that is the institution of the university system and of public education: ethics, politics, metaphysics, physics, mathematics, mechanics, biology, medicine, botany, agriculture, philosophy, logic, cosmology, aesthetics, theater, dance, poetics, the soul, psychology, et cetera. Here I should note that we have only thirty-one of Aristotle's two hundred treatises, many of these merely in student lecture notes. This Lyceum, around which Aristotle would walk while lecturing, was a temple dedicated to Apollo Lyceus (Apollo the Wolf-God).

ALEXANDRIA'S LYCEUM

In a conscious effort to continue the Aristotelian tradition and to improve the educational status of the young nation, in 1826, Josiah Holbrook began the Lyceum movement, a form of continuing education through lectures, discussions and debates featuring traveling lecturers such as Emerson, Thoreau, Twain, Douglass, Lincoln, Webster, Garrison, Anthony, Hawthorne, et alia. This classical education movement, in the Federal District (Alexandria, Virginia) linked to the Alexandria Library Company (the circulating library was by Benjamin Franklin initiated in British Philadelphia, 1731), caused the enthusiasm, which by $25 subscriptions ($575, 2017 inflation), funded the construction of the District's Lyceum building, a correct, Greek Doric villa. The Lyceum continued in operation until 1861, when commandeered by Union troops for hospital use.

LYCEUM CONVENTION

Following the riotous disturbance between contraband and Confederate soldiers (Christmas 1865), on March 2, 1867, radical Republicans and several hundred African Americans convened at the Lyceum, demanding full American citizenship and the right to vote. The right to vote was granted,

The Lyceum, Alexandria, Virginia; Benjamin Hallowell, architect, 1839. *The Lyceum.*

yet these votes for the Republican candidates were uncounted; concurrently, Democratic Confederates were removed from municipal office, elections were canceled and citizens who voted for Secession were disqualified from holding office.

APPOMATTOX STATUE

Alexandria witnessed the first violence in the War Between the States when Colonel Ellsworth was shot by Captain Jackson for removing the Confederate flag from King Street's Marshall House Inn, a flag that was visible from the White House. Captain Jackson was then shot by Union soldiers; both men died. The total number dead in what will here be named the "War to End Slavery" is recently estimated at 750,000; 1 in 10 (Caucasian men of fighting age, ten to forty-four) in the Northern states, 3 in 20 in the South. The statue commemorating Alexandria's citizens who died in the war, the Appomattox Statue, is located at Washington and Prince Streets, at the foot of the Lyceum. The statue depicts a handsome, uniformed Confederate soldier, head bowed, hat in hand, facing south toward Appomattox Court

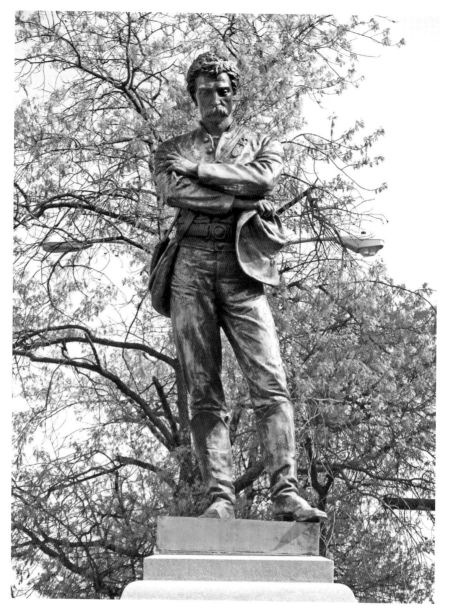

Appomattox Statue, Alexandria, Virginia; Caspar Buberl, sculptor, 1889. *Office of Historic Alexandria.*

House, where Alexandria's General Robert E. Lee surrendered to Ohio's General Ulysses S. Grant; Appomattox, where both American slavery and the American South ended. With the force of anger, the 2016 Alexandria City Council voted to remove the statue; with the strength of argument, in redacted passages from the Declaration of Independence, Thomas Jefferson faulted our British king for slavery and demanded the redress of wrongs (see glossary, Declaration Redaction). A final note: Benjamin Hallowell (architect of and lecturer at Alexandria's Lyceum) was Robert E. Lee's teacher before Lee left Alexandria for West Point.

GEORGE WASHINGTON MASONIC NATIONAL MEMORIAL (1922–1932)

Architect: Harvey Wiley Corbett
Sculptor: Bryan Baker, Donald De Lue, et alia
Painters: Allyn Cox, et alia

FREEMASONRY

The art, the craft, the trade of carving stone is traditionally handed up from master to apprentice to apprentice. In Western Civilization, some locate masonry's beginnings in Egypt, some in Greece, some in Europe's medieval guilds where freemasons (those not in serfdom, from the Latin *servus*, slave) shared common greetings, took oaths, wore emblems and abided by a code of morals in a brotherhood of common support. Ethically, I can say that stone carving, that any art practiced truly cannot abide the lie, sloth, impatience, hubris, and that neglect which weakens the work and debilitates the craftsman. In crafts of building, in construction ethical and material, vice is deadly. No one has yet died from a Jackson Pollock, except Jackson Pollock.

Long ago, freemasons abandoned tutelage in stone-craft for apprenticeship in virtue, that "beautiful system of morality, veiled in allegory and illustrated by symbols" derived from stonemason tools, each tool embodying some ritualized merit. In time and by degree, Freemasons are initiated from apprentice, to fellow craft, to master mason, each initiation touching on the

Temple of Solomon's mysteries, the artistry and the death of the temple's architect, Hiram Abiff. Masons swear to secret each degree, to protect Masonic brothers who keep sacred Masonic law. Some wonder at this: We classicists remember sacred rites, the sects, and the Eleusinians who kept the mystery some two thousand years.

The fabulous claims of Freemasonry's antiquity are, in this instance, less compelling than is historical anecdote: That first document of Freemasonry, the Halliwell document, circa 1390, prescribes that masters and fellows of the craft should be "steadfast, trusty, true and upright," that apprentices should be of lawful blood and have limbs whole; that, in 1734, the moralist Benjamin Franklin, at Philadelphia (City of Brotherly Love), printed America's first Masonic book. Fifty years later, in 1783, the Alexandria Lodge was founded (year of the Treaty of Paris, which concluded the War of Independence); that in the year George Washington was by electors chosen president of these United States, 1788, the Lodge was rechartered under George Washington, charter master. In 1804, five years after Washington's death, efforts were begun to rename the lodge "Virginia-Washington Lodge No. 22" to "honor a departed brother"; that Paul Revere, Hancock, Lafayette and Baron von Steuben were Masons; that a steadfast, true and upright Mason, Chief Justice John Marshall, shaped the United States Supreme Court.

PHAROS OF ALEXANDRIA

Plutarch reports that the conqueror Alexander the Great founded seventy cities; his first, Alexandroupolis, when sixteen; his fourth, Alexandria, Egypt, when twenty-five, in 331 BC, the year he defeated the Persians at Guagamela. In Egypt's Alexandria, on the Island of Pharos, is found the Lighthouse of Alexandria, constructed by Ptolemy I, Sorter (Savior), general for and perhaps half brother of Alexander. This lighthouse was the world's first, at 350 feet the tallest building in the world, after Pharaoh Khufu's great pyramid. The Pharos is counted among the Seven Wonders of the World, as much for its height as for its use, extraordinary beauty, and powerful symbolism.

GEORGE WASHINGTON MASONIC
NATIONAL MEMORIAL

At the summit of the London-inspired Shooter's Hill, where Union troops encamped during the War to End Slavery, above Alexandria, overlooking the Capitol, we find the ascendant of Alexandria's Pharos, a temple to the Master Mason General George Washington, victor at Trenton, Boston, Princeton and Yorktown, our liberator who accepted the surrender of the British Empire, a steadfast, trusty, upright, true and excellent person, a virtuous man, the first president of these United States. The temple was designed by Harvey Wiley Corbett, alumni of the École des Beaux-Arts, a classicist, a pioneer of skyscrapers who understood development within the classical tradition. In design, Corbett inherited the testimony of a traveling Arab who in 1166 described the lighthouse as being constructed of light-colored blocks, of three tapering tiers, et cetera; and the evidence of Roman coins struck at Alexandria showing the whole surmounted by a statue. Corbett added a tier, replaced the statue with a pyramid and, with republican taste, mediated Hellenistic excess to compose a great masonry monument of Greco American design, an allegorical lighthouse projecting enlightenment over a cynical world. I leave the final word on British America to the laconic General George Washington, who said, "I didn't fight George the Third to become George the First."

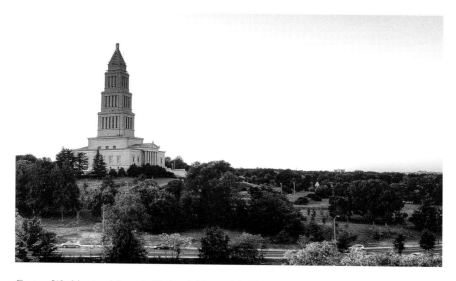

George Washington Masonic National Memorial, Alexandria, Virginia; Harvey Wiley Corbett, 1932. *Office of Historic Alexandria, Mike Donohue.*

EPILOGUE
CONTEMPORARY MEMORIALS

TOUR SITES

THE EISENHOWER MEMORIAL

THE NATIONAL LIBERTY MEMORIAL

CONTEMPORARY MEMORIALS

PREFACE

We recall that long before human habitation, on that land bordered by the confluence of two slow, wide rivers was found what we now understand to be Washington, the District of Columbia; we recall the layer upon layer of monument and memorial that enlarge the experience of our heritage; we recall that buildings and memorials enrich our lives in beauty, in meaning, in national purpose; we Americans recall the deeds and principles worthy of remembrance; the rest we forget. At the composition of this book, two major monuments are being considered by the American people, the press and the politicians: the progressively conceived Eisenhower Memorial and the classically conceived National Liberty Memorial. The choice we take and the memorials we construct will make of us, our children and their ascendants one type of people or another, or some hybrid of citizenry that we cannot now foresee. This consideration of a progressive and a classical memorial will test the precept of founding principles and try our fealty to the nation's founders. Please, with me consider these two memorials.

OF TERMS

Of terms, Modern, Classical, Progressive, more can be said than space will allow, yet these words embody philosophies that form persons and shape

civilizations. Briefly, "Modern" is the notion first expanded by the satirist Jonathan Swift in describing the battle of books "classical" and "modern," the classical representing the ancients, the "modern" representing the XVIII-Century contemporary. The literary battle was fierce and frantic in ripping, tearing and mayhem, each side in turn noble and well spoken, each side in good form, yet, although the mods recommended promise, it was acknowledged that all that was modern was dependent on classical precedent: With reservation, the ancients triumphed. "Classical" is that living tradition of beauty, liberty, and logic we find in each word we speak, in all layers of meaning in ideas, sciences and arts; the classical was born in the humane, the urbane harmony of health in the individual mind and body; the classical abides in each person who acknowledges that the internal, divine presence is found in creatures of our type and of other types divinely created; the classical recognizes the sublime-divine in all things. "Progressive" is the assumption that through science, perfection will be achieved in body, behavior, society and government; progressivism is the belief that all the universe is material, that all materials can be known, that when by science all is known, science will find its end and all problems will be resolved.

OF ASSUMPTIONS

Some assume this universe to be physical; some assume this and all possible universes to be dual, both physical and mindful; each assumption causes effects within a person, a society, a government and here, in our consideration, the form of monuments and memorials. Imagine a person blind, yet through reading and listening this person comes to learn the complete science of the eye, the science of all things, buildings, trees, persons, planets, of color and all that in description through science can be learned. Now imagine that by surgery or miracle the person comes to sight, and seeing all that is, by the flash of the experience, this person in body and mind comes to knowledge. Learning through science is physicalism, it is progressive, a supposition that nothing outside the physical has existence; knowing through the body of the mind is "dualism," it is classical, a supposition of reality supra-corporeal. As I like to say, "The universe knows itself by the mind of man." You will recognize that classical dualism assumes a meaning and purpose within forms, that progressive physicalism assumes no meaning in forms except in the physical thing itself, and this is

why the classical creates beautiful, humane statues containing genius and why the progressive creates things of rusted bent metal and twisted colored plastic devoid of internal genius, being as they are, the material substance of the object alone.

THE MODERN

Both the classical and the progressive contain the modern, both are contemporary and both ascend from the ancients through philosophy, yet the progressive denies its antiquity while the classical acknowledges its tradition. Apart from the corporeal world, all that we see was in the first instance designed by the artist; our civilization is an aesthetic construction formed of ideas that form and reform us. We cannot, in fact, say that the competing progressive and classical philosophies resolve themselves into political parties, yet the philosophical tendencies do form persons, monuments and memorials that are recognized in parties social and political. Here I should mention that Aristotle did not say, "Man is a political animal," that mistranslation satisfying to Darwinists; Aristotle said that "man is a social animal," as are bees and swans, intending that we live in a social environment suitable to our nature. The question before us: Are we merely physical creatures, or are we divine creatures that transcend the physical? The answer to this question will determine the shape of our monuments, our memorials, our city and our future.

THE EISENHOWER MEMORIAL
(1999–PRESENT)

Architect: Frank Gehry

Because it is important that American citizens assume responsibility for our national memorials, it is here necessary to discuss a memorial under deliberation, a memorial very much in the news, news that should, in some measure, be recorded by history, either as conversation of principles, if built, or as historical curiosity, if unbuilt. So, we should know that at the open space in front of the Lyndon B. Johnson Building, behind the Air and Space Museum, on the plot where are found curiously quaint hippie-like herb and vegetable gardens, is planned an enormous, typically progressive, pretentious Frank Gehry monument, a memorial to General Eisenhower. The Gehry monument features gargantuan, eight-story concrete piers—think the Dallas High Five Interchange but higher—draped with an eighty-foot-high cyclone fence scrunched into an approximation of the Normandy seascape, a scrunch below which linger little bronze, pedestrian figures overborne by big dumb blocks and you can picture the monument, for free. To build the Gehry monument, $150 million is required, which, in typical progressive fashion, is $85 million over the original estimate. To fund the commission, its members and contractors, $35 million has been spent before a shovel has been footed into the ground, before a final design has been approved. Here it should be mentioned that progressivism is big, that Gehry's monument could consume within itself the Washington, Jefferson and Lincoln Memorials, that the various government "watchdog" agencies (NCMAC, NPS, GSA,

NCPC, CFA) have provisionally, unanimously approved the monument and that the United States House of Representatives, the people's house, has, for good cause, halted future funding.

Former editor of the *New Republic*, current contributor to the *Washington Post* Philip Kennicot accurately describes the memorial's philosophical precepts: "Gehry has produced a design that inverts several sacred hierarchies of the classical memorial.... [He] has re-gendered the vocabulary of memorialization." Rocco Siciliano (friend of Gehry, chairman of the Eisenhower Memorial Commission) and Senator Stevens intended an "out-of-the box" memorial, one that would incorporate an "e-memorial"—an e-memorial is a species of electronic gadgetry that dictates to a memorial (or museum) visitor how the memorial should be seen, what the visitor should think, and why the thing came to be; you will here recognize that a memorial's meaning is what the expert (scientist) tells you it should be, that the physical structure is a creatively unique expression of an artist, an expression differing from the person, principle or deed memorialized, in this instance, the American hero Dwight D. Eisenhower, soldier, general, college president and president of these United States.

FIGURATIVE SCULPTURE

Figurative sculpture is the progressive's name for statuary. The name was created to demote statues of exemplary citizens, heroes and iconic divinities into a subcategory of "sculpture," subcategories that include abstract, non-objective, kinetic, earth-work, et cetera. You will notice that statuary and decorative elements are not included in, on or around Washington, D.C.'s pockets of progressive buildings. This causes a manner of blight, a desert of nihilism within a city humanely beautiful. When Gehry unveiled his enormous design for the front of the LBJ Building, there was one figurative sculpture of the twelve-year-old Dwight overwhelmed by towering piers, vast acreage and looming, scrunched fences: Progressivism is friendly to theory, unfriendly to humanity.

THE NATIONAL LIBERTY MEMORIAL (2013–IN PROGRESS)

Architects: Franck & Lohsen Architects
Sculptor: David Newton

NEGLECTED PATRIOTS

We remember many great Americans who fought for our national and political liberty: Washington, Jefferson, and Laurens we remember and we honor. The honor due to these great men would not have been possible without the brave soldiers who served the cause of liberty. Rightly, the service of many patriot soldiers has been recognized; unfortunately, the service of some patriots has been neglected by history, those patriots by the ancient practice of slavery bound to serve the will and convenience of another: These neglected patriots are the object of this consideration.

WILLIAM LEE

On a stroll from Hamilton to the National Liberty Memorial, we see on our right the unadorned Washington Monument centered, as it should be, in the nation's capital city; to our left, rudely shouldering into the open, common space of Liberty's lawn, our National Mall, the gaudi crown of the African American Museum, a token of imperial Yoruba monarchy, an

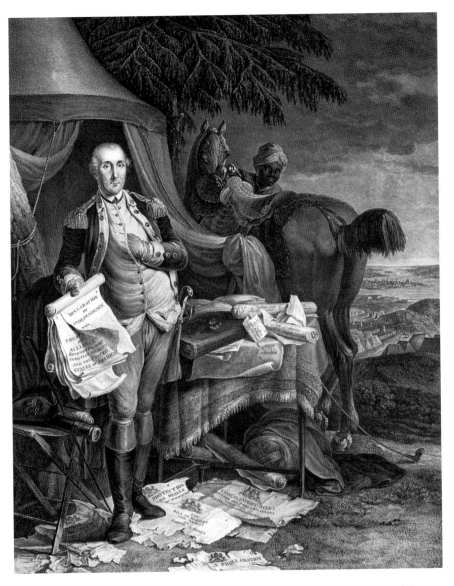

Le Général Washington, Ne Quid Detrimenti Capitat Res publica, engraving; Noel Le Mire, circa 1785. *Library of Congress.*

African monarchy of brutal slave takers, slave owners and slave traders, here a rich bit of dark irony; before us, the Department of Agriculture's Whitten Building, site of the National Liberty Memorial. The Agriculture Building seems a most appropriate place to honor those who by force or

217

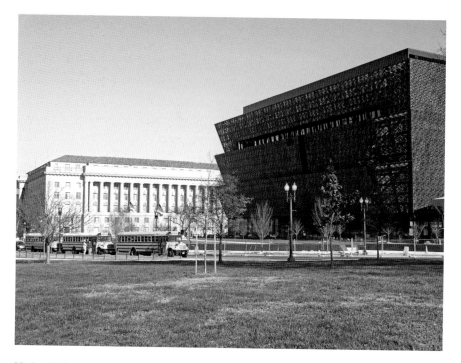

National Museum of African American History; David Adjaye, et alia, architects, 2016. *KAD Photo.*

favor did so much to bring health and bounty to their fellow Americans. I am reminded of Will Lee, mulatto, slave, valet to General Washington during the war, a brave soldier devoted to the General and the cause of liberty—which for him was staked higher than most—his manumission at George Washington's death, and Mr. Lee remaining at his home of Mount Vernon, trading stories with fellow veterans, family and friends for the remaining twenty-nine years of his rich, full and free life. You will find Mr. Lee pictured in many gilded frames standing alongside the General: It is for Mr. Lee, and those five thousand others of apportioned African ancestry who fought for national liberty, that the memorial will be placed here, with agriculture, alongside General Washington's monument, in their own memorial where we might, with particular gratitude, acknowledge our debt to these remarkable Americans.

LIBERTY'S AXIOM

The struggle for independence is every American's story. We see the Declaration of Independence as a call to oppose tyranny and slavery. We reason that the phrase "all men are created equal" is a self-evident truth that contains a promise to all Americans, and by nature, through time and action, the promise of this truth is being extended to the diverse peoples of the world. "All men are created equal" is Liberty's axiom and is explained by Thomas Jefferson, "that they [men] are endowed by their Creator with certain unalienable Rights, that among these are Life, Liberty, and the Pursuit of Happiness." Far too many persons continue in servitude through communism and Islam, and we foundational Americans continue in fealty to Liberty's axiom, extending liberty in these states and other states beyond our shores.

LIBERTY PATRIOTS

For over two hundred years, there has been a consensus that American soldiers and Patriots of West African ascent who served in the War of Independence from Britain deserve a unique recognition. This consensus is rooted in the patriotism of enslaved Americans: Of Salem Poor, "hero at the Battle of Bunker Hill"; of Peter Salem, who fought at Concord, Saratoga and Stony Point; of those who were honored for bravery, those who served with distinction, and those who sacrificed their lives that our nation might be born. These free and enslaved Americans performed countless patriotic acts in the cause of independence, in the creation of these United States, in the eventual abolition of slavery and in the possible extension of personal liberty to all men in all nations for all time. To honor these forgotten Patriots, the United States Congress has directed the creation of the National Liberty Memorial. This classical memorial will express our historic American values at work in the nation's founding by demonstrating the achievement of free and enslaved Americans who fought for our nation's liberty.

LIBERTY PATRIOT STATUE

The first state of the statue represents an American Patriot soldier in arms, West African in feature and form, his wife holding the Old Glory

flag, and their son, a little drummer boy who, it is hoped, will enjoy the liberty for which his father fights. You will notice that the statue derives from those models of statuary known in classical Greece; you will recognize the similarity to other statues representing heroes of our war for liberty; you will likely agree that the statue is in a style admired by our founding generation, a style most pleasing to contemporary generations, a style that would have been expected by those whom we honor, a style in the classical idiom of the nation's founding. (See the L'Enfant Plan and McMillan Plan.) You probably should know that there has been a spitting opposition to the statue of the memorial by progressives entrenched deep in the bowels of bureaucratic function, an opposition that has for years delayed the realization of a memorial granting honor to our Liberty Patriots. The progressives, seeing in all new objects of the capital opportunity for propaganda, have stalled, undermined, lobbied to claim the memorial and too transfigure our patriots into meaningless twists of unbodied metal, into bright, vacuous baubles, into shapes of concepts foreign to our Patriots, shapes upon which would be attached labels whose intent is to divert understanding from foundational liberty, redirecting attention toward fictions of progressive inevitability.

Worthy of note: The National Liberty Memorial was inspired by Lena Santos Ferguson, who diligently persisted in application of admission to the Daughters of the American Revolution after the DAR denied her application based on race. Ferguson was successful in admission and became an honored DAR member. In recompense for the unjust denial of Ferguson's application, the DAR published *Forgotten Patriots: African American and American Indian Patriots in the Revolutionary War*.

THE GREEK ARCHITECTURAL ORDERS

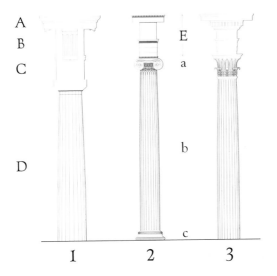

1. The Greek Doric
 From the Parthenon, Athens; Iktinos and Callicrates, architects; 447–432 BC
2. The Greek Ionic
 From the Erechtheion, Athens; Mnesicles, architect; 421–406 BC
3. The Greek Corinthian
 From the Tower of the Winds, Athens; architect unknown; II or I Century BC

A. Cornice
B. Frieze
C. Architrave
D. Column
E. Entablature (inclusive of cornice, frieze, and architrave)

a. Capital
b. Shaft
c. Base

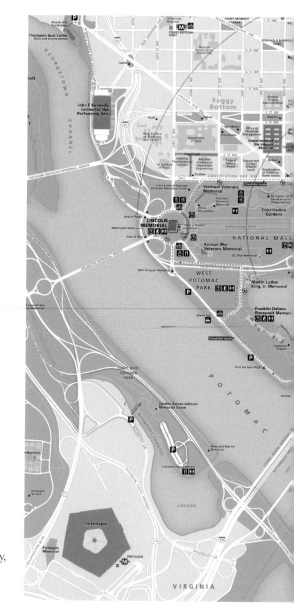

Old Town Alexandria, once incorporated within the one hundred square miles of Washington, the District of Columbia, is located seven miles south of the Pentagon and is accessible by metro, by auto along the George Washington Memorial Parkway, or by water-taxi down the Potomac. *The National Park Service.*

APPENDIX II

WASHINGTON, D.C. SITE MAP

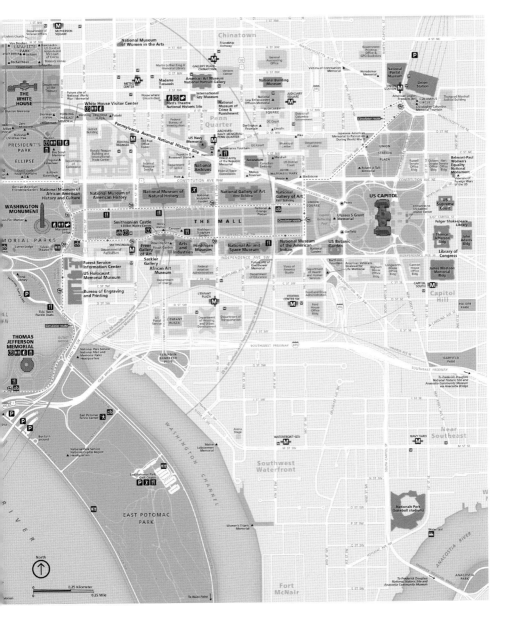

HISTORIC DOCUMENTS

Declaration of Independence, Abridged

The unanimous Declaration of the thirteen united States of America: When in the Course of human events, it becomes necessary for one people to dissolve the political bands which have connected them with another, and to assume among the powers of the earth, the separate and equal station to which the Laws of Nature and of Nature's God entitle them, a decent respect to the opinions of mankind requires that they should declare the causes which impel them to the separation.

We hold these truths to be self-evident, that all men are created equal, that they are endowed by their Creator with certain unalienable Rights, that among these are Life, Liberty, and the pursuit of Happiness.—That to secure these rights, Governments are instituted among Men, deriving their just powers from the consent of the governed,—That whenever any Form of Government becomes destructive of these ends, it is the Right of the People to alter or to abolish it, and to institute new Government, laying its foundation on such principles and organizing its powers in such form, as to them shall seem most likely to effect their Safety and Happiness. Prudence, indeed, will dictate that Governments long established should not be changed for light and transient causes; and accordingly all experience hath shewn, that mankind are more disposed to suffer, while evils are sufferable, than to right themselves by abolishing the forms to which they are accustomed. But when a long train of abuses and usurpations, pursuing invariably the same

Object evinces a design to reduce them under absolute Despotism, it is their right, it is their duty, to throw off such Government, and to provide new Guards for their future security.

Declaration of Independence, Redaction

...He [George III] has waged cruel war against human nature itself, violating its most sacred rights of life & liberty in the persons of a distant people who never offended him, captivating & carrying them into slavery in another hemisphere, or to incur miserable death in their transportation thither. This piratical warfare, the opprobrium of *infidel* powers, is the warfare of the CHRISTIAN king of Great Britain. determined to keep open a market where MEN should be bought & sold, he has prostituted his negative for suppressing every legislative attempt to prohibit or to restrain this execrable commerce: and that this assemblage of horrors might want no fact of distinguished die, he is now exciting those very people to rise in arms among us, and to purchase that liberty of which *he* has deprived them, by murdering the people upon whom *he* also obtruded them; thus paying off former crimes committed against the *liberties* of one people, with crimes which he urges them to commit against the *lives* of another....In every stage of these oppressions we have petitioned for redress in the most humble terms; our repeated petitions have been answered by repeated injury. A prince whose character is thus marked by every act which may define a tyrant, is unfit to be the ruler of a people who mean to be free. Future ages will scarce believe that the hardiness of one man, adventured within the short compass of 12 years only, on so many acts of tyranny without a mask, over a people fostered & fixed in principles of liberty.

BIBLIOGRAPHY

Bedford, Steven. *John Russell Pope, Architect of Empire*. New York: Rizzoli International, 1998.

Bryan, John M., ed. *Robert Mills: Architect*. Washington, D.C.: AIA, 1989.

Christian, Barbara S., ed. *Cass Gilbert, Life and Work: Architect of the Public Domain*. New York: W.W. Norton & Company, 2001.

Cox, Ethelyn. *Historic Alexandria, Virginia, Street by Street: A Survey of Existing Early Buildings*. Alexandria, VA: Historic Alexandria Foundation, 1976.

Fortier, Alison. *A History Lover's Guide to Washington, D.C.: Designed for Democracy*. Charleston, SC: The History Press, 2014.

Goode, James M. *Washington Sculpture: A Cultural History of Outdoor Sculpture in the Nation's Capital*. Baltimore, MD: Johns Hopkins University Press, 2009.

Greenberg, Allen. *The Architecture of Democracy*. New York: Rizzoli International, 2006.

Grundset, Eric G., ed. *Forgotten Patriots: African American and American Indian Patriots in the Revolutionary War, A Guide to Service, Sources and Studies*. Washington, D.C.: National Society Daughters of the American Revolution, 2008.

Gurney, George. *Sculpture of the Federal Triangle*. Washington, D.C.: Smithsonian Institution, 1985.

Harvey, Fredrick Loviad. *History of the Washington National Monument and of the Washington National Monument Society*. Charleston, SC: Forgotten Books, 2013.

Highsmith, Carol M. *Union Station: A History of Washington's Grand Terminal*. 2nd ed. Washington, D.C.: Union Station Venture, 1998.

Hovey, Lonnie J. *Lafayette Square; Images of America*. Mount Pleasant, SC: Arcadia Publishing, 2014.

Jaeger, Warner. *Paideia: The Ideals of Greek Culture*. Vol. 1: *Archaic Greece: The Mind of Athens*. Gilbert Height, trans. New York: Oxford University Press, 1986.

Jefferson, Thomas, et alia. *The Declaration of Independence*. Philadelphia, 1776.

Jordy, William H. *American Buildings and Their Architects: Progressive and Academic Ideals at the Turn of the 20ᵗʰ Century*. New York: Doubleday, 1976.

Lowry, Bates. *Building a National Image: Architectural Drawings for the American Democracy, 1789–1912*. Washington, D.C.: National Building Museum, 1985.

Madison, James, et alia. *The Bill of Rights*. Philadelphia, 1789.

Mann, Nicholas R. *The Sacred Geometry of Washington, D.C.: The Integrity and Power of the Original Design*. New York: Barnes & Noble, 2006.

Miller, Iris. *Washington in Maps*. New York: Rizzoli International, 2002.

Moeller, G. Martin, Jr. *A Guide to the Architecture of Washington, D.C.* 5th ed. Baltimore, MD: Johns Hopkins University Press, 2012

Moore, Gat Montague. *Seaport in Virginia: George Washington's Alexandria*. Richmond, VA: Garrett and Massie, 1949.

Morris, Gouverneur, James Madison, et alia. *The United States Constitution*. Philadelphia, 1787.

Peterson, Merrill D. *Jefferson Memorial: Interpretive Guide to Thomas Jefferson Memorial, District of Columbia*. Washington, D.C.: National Park Service, 1998.

Reed, Henry Hope. *The United States Capitol: Its Architecture and Decoration*. New York: W.W. Norton & Company, 2005.

Reps, John W. *Washington on View: The Nation's Capitol Since 1790*. Chapel Hill: University of North Carolina Press, 1991.

Richman, Michael. *Daniel Chester French, an American Sculptor*. Landmark Reprint Series, Metropolitan Museum of Art. Washington, D.C.: National Trust for Historic Preservation, 1983.

Scott, Pamela, and Antoinette J. Lee. *Buildings of the District of Columbia*. New York: Oxford University Press, 1993.

Seale, William. *The President's House*. Washington, D.C.: White House Historical Association, 1986.

Small, Herbert. *The Library of Congress: Its Architecture and Decoration*. Classical America, the Arthur Ross Foundation. New York: W.W. Norton & Company, 1982.

BIBLIOGRAPHY

Thomas, Christopher. *The Lincoln Memorial and American Life*. Princeton, NJ: Princeton University Press, 2002.

Vietnam Veterans Memorial Directory of Names. Washington, D.C.: Vietnam Veterans Memorial Fund, 1986.

WEBSITES

Library of Congress. L'Enfant Plan of Washington. www.loc.gov/exhibits/us.capitol/twtynine.jpg.

National Civic Art Society. Washington, the Classical City. www.civicart.org/video_washingtonclassicalcity.html.

INDEX

ABOUT THE AUTHOR

A classical painter, sculptor, architect and poet, Michael Curtis has plays, translation and verse published in over thirty journals, including *Trinacria*, *Amphora* (the American Philological Association), *The Pennsylvania Review*, *The Society of Classical Poets*, et cetera, and his many books and articles in fiction and nonfiction attest to an abiding interest in civil society. Too, Curtis has taught and lectured at universities, colleges and museums, including the Institute of Classical Architecture, the Center for Creative Studies and the National Gallery of Art. His pictures and statues are housed in over three hundred private and public collections, including the Library of Congress, the National Portrait Gallery and the Supreme Court; his public statues include *General Eisenhower*, *Justice Thurgood Marshall*, *The History of Texas*, and various portraits and medals, *George Washington* for the National Portrait Gallery, *James Madison* for the Federalist Society; his buildings, houses, monuments and memorials are found coast to coast, et cetera. Curtis consults on scholarly, cultural and artistic projects, currently: curator, Plinth & Portal (a history of architecture website); vice president, Liberty Fund, D.C. (authorized by the U.S. Congress to create a memorial honoring African Americans who served in the War for Independence); director of design and planning, AEGEA (a new fifty-eight-square-mile city in central Florida).